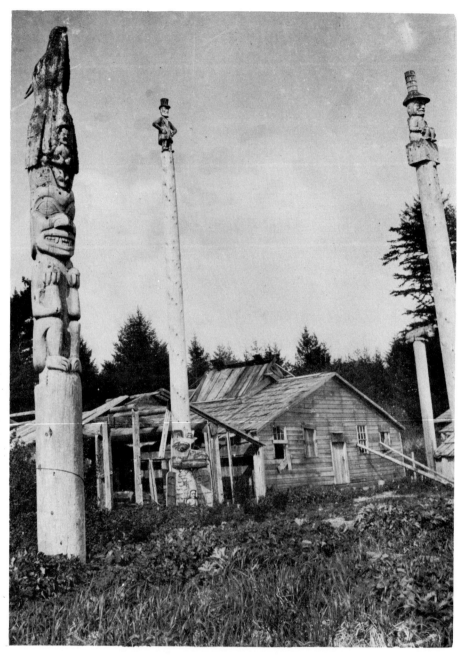

Lincoln and Seward Poles, Tongass Village

THE
WOLF AND THE RAVEN

Totem Poles of Southeastern Alaska

by
Viola E. Garfield and Linn A. Forrest

seattle and london
university of washington press

PREFACE

FOR MANY YEARS the United States Forest Service recognized the necessity of collecting and restoring the totem poles to be found throughout southeastern Alaska if any evidence of this unique art was to be preserved. Not until the fall of 1938, however, were funds available so that work of this nature could be undertaken by the employment in the Civilian Conservation Corps of skilled native carvers.

Since most of these totem poles were in deserted native villages inaccessible to regular steamer routes, the Forest Service desired to locate them more centrally where visitors to Alaska might enjoy these carved memorials. Gaining permission to move the poles was the first task—and a difficult one, because ownership was vested in lineages, not in individuals. The excellent cooperation of the natives soon overcame this obstacle, however, and the poles are now located on public land where they will be preserved for the benefit of future generations.

The poles in Saxman Totem Park, three miles from Ketchikan, were restored by Tlingit natives, many of whom are descendants of the original owners. This group of poles includes carvings from Cape Fox Village, Tongass Village, Village Island, and Pennock Island. Chief Johnson's totem pole in Ketchikan was also restored by carvers at the Saxman workshop. Two new poles symbolic of old Tlingit legends were designed and carved for the totem village at Mud Bight, a few miles north of Ketchikan. A model village was planned for the latter site, but the war prevented completion of the project. The poles in the Klawak Totem Park were brought from the de-

serted town of Tuxekan and vicinity. Some of the men who worked on the restoration project were born in the old town, and all had ancestors who had lived there.

Totem-pole carvings cannot be appreciated or understood without a knowledge of the legends and histories back of them. The Regional Forester of Alaska, B. Frank Heintzleman, was therefore particularly anxious to collect such information. Linn A. Forrest, the Regional Architect, was placed in charge of the totem pole restoration project. To him and other Forest Service members were entrusted the selection and removal of the old carvings, the arrangement and erection in new parks, and the securing of the totem stories and photographs. Charles Brown, head carver for the Saxman workshop, in which many of the carvings were restored, also recorded many of the legends and consulted with his tribesmen when his own memory or knowledge failed him. To many other Tlingit men and women who cooperated in the preparation of this account of their carvings thanks are due, for it is their art and only they can explain it.

Dr. Viola E. Garfield, Department of Anthropology of the University of Washington, Seattle, Washington, was entrusted with the task of assisting in the collection of information and the editing of the handbook.

<div align="right">

VIOLA E. GARFIELD
LINN A. FORREST

</div>

CONTENTS

ILLUSTRATIONS

(All photographs by Otto Schallerer, Ketchikan, Alaska, unless otherwise noted)

Frontispiece. Lincoln and Seward Poles, Tongass Village
(Photo by S. Riley, U. S. Forest Service, 1919-21)

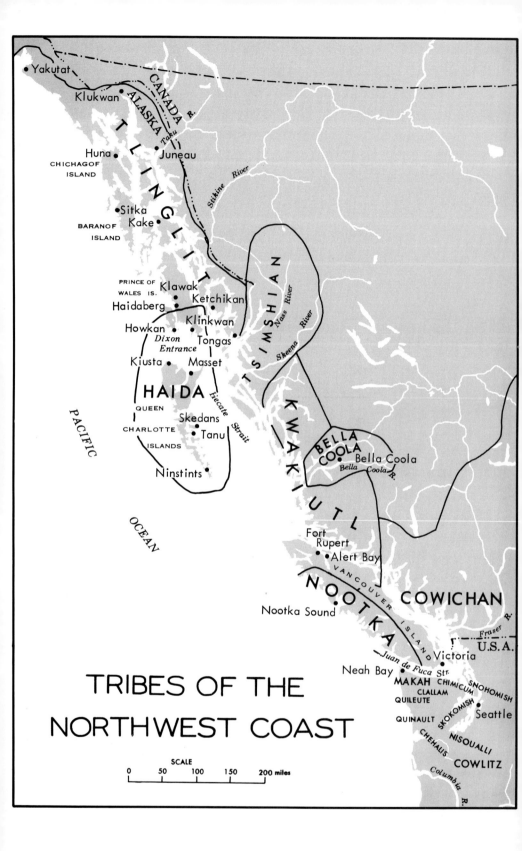

TRIBES OF THE
NORTHWEST COAST

INTRODUCTION

TOTEM POLES have attracted the attention and aroused the curiosity of all who have seen them. These sculptured columns, sometimes exceeding sixty feet in height, on which appear birds, animals, and strange unrecognizable creatures, are carved nowhere else in the world. They are unique in the small area of southeastern Alaska and western British Columbia where the Tlingit and other Indians developed a highly characteristic art style and applied it to many of their handicrafts.

Totem-pole carvings illustrate legends and serve as lineage crests. While the conventionalized figures employed by the artist provide many clues to the *identity* of the legendary characters he has carved, the *interpretation* of his craftsmanship is not simple. It can be made only by those who know the native myths. The figures symbolize both characters and events of the mythological age and the experiences and adventures of known ancestors and living persons. For example, numerous myths are told of Raven, a myth-age hero and transformer, and many of the carvings symbolize him. The legendary catastrophic world flood, the migrations, wars, and other happenings that have impressed themselves upon the people's memories have also been put into carvings.

Totem poles are the largest and most spectacular but by no means the only objects on which the Northwest Coast natives have illustrated their legendary and actual history. Ingeniously made chests, ceremonial paraphernalia such as rattles, headdresses, and staffs, personal ornaments, the posts supporting

1

the house beams, and the fronts of old plank houses have been decorated with similar symbolism.

Before tempered iron and steel blades were introduced into Alaska, the Indians made adze blades of jadeite and other hard stone; axes were unknown. Details were done with knives and chisels with cutting edges of stone, shell, or beaver teeth. With such crude tools intricate carving was a slow and laborious process, even on soft wood. It is probable that in this epoch the largest sculptures attempted were those on house posts and short mortuary columns.

The acquisition of metal cutting blades in the latter part of the eighteenth century facilitated more complex carving and increased the production of individual artists. The tall totem pole, set in front of the owners' house, was a late product, made possible by more efficient tools and the greater wealth brought by the fur trade of the early nineteenth century.

Before the opening of the nineteenth century, artists had developed a conventionalized art style in which certain symbols were selected for the identification of characters who figured most frequently in the myths. An important factor in such conventionalization may be found in the nature of the characters depicted. Many of them were capable of changing form at will and were also capable of marvelous feats transcending the powers of animals and men in the present-day world. Often the artist desired to show transformations of myth characters in his carvings. For example, Raven created man, brought daylight, arranged the rivers and lakes, and indulged his fondness for adventure. But as he traveled about the world he changed form as occasion demanded. He often appeared as a man and concealed his supernatural identity. To accomplish other desired ends he might become a woman, a child born of a chief's daughter, or a hemlock needle. He dived beneath the ocean, lived in a whale, or ascended to the skies merely by willing to do so. Raven is therefore depicted in each instance according to

2

his role in the legend that is illustrated. However, since he frequently appeared in bird form, the carvers selected his straight beak as the special mark by which he may be distinguished from other birds or supernatural beings in bird form. Though he may be carved in any combination of bird and human characteristics, the straight beak clearly identifies him.

Certain other symbols were used by almost all the carvers and may be recognized by any casual observer. Claws, wings, and beaks of conventionalized form identify birds or their human forms; fins or fluted tails identify fish or sea mammals; a pointed snout, sharp teeth, and claws identify bear or wolf. Halibut and frog were usually drawn more realistically than other characters and are readily recognized. Beaver may be recognized by large incisor teeth, a stick held in his front paws, and a scaly, paddle-shaped tail. One or more of these symbols is present in every carving which symbolizes beaver.

An oval design, an eye, or a face may represent joints of the body. Such motifs also symbolize spirit or power. Used on wings, they symbolize the power of flight; in the ear, the faculty of hearing or comprehension and association; in the eye, the vital force or life principle. On the other hand, conventionalized feathers, bird tails, fins, and certain other motifs are also often used to decorate surfaces without any particular significance or legendary connotation.

To satisfy artistic requirements the carver had to represent as much of the subject as possible. If space did not permit carving the whole figure, he selected certain identifying marks and included as much else as he could. Since carving on a pole was usually limited to approximately half of the circumference of the tree trunk after the bark was removed and since the center was often hollowed out, the artist had only a narrow, curved surface to decorate. Its length, narrowness, and upright position influenced the arrangement of figures or motifs. Animals, humans, and birds had to sit or stand with their limbs drawn

tightly to their bodies, or sometimes they "dived" head first down the pole. Often they were distorted into unnatural positions to fit the allotted space. On many poles compactness was achieved by carving one figure on another and by interlocking a figure with those directly above and below it. To achieve greater depth and perspective in the carvings, separate wings, beaks, fins, or whole figures were sometimes carved and fastened to the pole.

Comparison of Cape Fox and Tongass carvings with those from Tuxekan reveal differences in treatment that make them easy to distinguish. The former had large trees to work with. The Seattle Totem Pole, for example—one of the largest from Tongass—measures fifty-nine feet in height and has a diameter of nearly four feet. Tuxekan, on the northwest shore of Prince of Wales Island, was near the northern border of the western red cedar belt, where the trees were small and scattered. Carved columns made from them are slender and short, measuring from two to three feet in diameter at the base and from ten to thirty feet in height. Working with smaller timbers, Tuxekan carvers developed slender, elongated figures that have a pinched look, especially when viewed from the front. The base and other undecorated sections of nearly all Tuxekan poles are squared, and the carved figures tend to have the same outline. All other Northwest Coast tribes retained the half-moon shape of the pole in the finished carving, though sections bare of carving were sometimes finished in the round.

All Tuxekan poles are either grave markers or sepulchers for boxes containing the ashes of the deceased. There were no carvings set up for the sole purpose of advertising the wealth of an individual or a lineage, or to commemorate some special event, as at Tongass.

Except in rare instances, as on the Lincoln and Seward poles, the top figure is symbolic of the lineage or other group which owns the pole. It is that group's heraldic emblem or crest. Since

4

the Tlingit, as well as some of their Indian neighbors, trace descent only through the mother's lineage, these crests are not family insignia, but belong to lineages or clans.

Each Tlingit belongs to one of two divisions or phratries termed Ravens and Wolves; Wolves are also called Eagles by some Tlingit tribes. All Ravens are relatives, as are all Wolves (or Eagles). Within these phratries are smaller groups or clans, whose members are more closely related. Clans are further subdivided into lineages or house groups. Children are born into, and take the name of, their mother's lineage, and hence are members of her clan and phratry also. Since marriage between members of the same phratry is forbidden, a man and his wife always belong to opposite phratries; one spouse belongs to a house group of the Raven phratry and the other to a house group within the Wolf or Eagle phratry.

Each lineage owns hunting districts, streams and bays where fish abound, homes, and other kinds of property. Homes were large structures built of cedar timbers with plank walls and split shake roofs. They were sturdily constructed to last a lifetime and were large enough to accommodate several families. A hereditary head or chief presided over each home and administered the property and affairs of its members. He did not personally own the home—it was the joint property of all the members of his lineage, including his mother and her brothers and sisters, his own brothers and sisters, and his sisters' children. His sisters' sons lived with him, and one of them inherited his duties after his death. Each dwelling was named, usually after some crest animal belonging to the owners, and they were referred to as people or members of such and such a house. In the following pages many house groups are mentioned as owners of carved columns. Some of the houses are Raven House, Eagle Claw House, Halibut House, and Dog Salmon House. Owners are referred to as people of Raven House, Dog Salmon House people, etc.

5

Each lineage also has a history which explains its remote origin and its development, though this history may be largely legendary. The crest of each lineage, which members use as a mark of identification, is usually derived from an encounter of legendary ancestors with a mythological creature. The raven crest is used by many lineages that belong to the Raven phratry, and the wolf is claimed by lineages of the opposite division. Some of the other crests are eagle, bear, sea lion, beaver, blackfish, and frog; all of these can be seen on poles in Saxman, Ketchikan, and Klawak.

In olden times each Tlingit also belonged to a hereditary class into which he was born, and out of which it was very difficult for him to escape. House and lineage heads and their heirs occupied the most favored social position and constituted the wealthy class. They controlled and administered all property belonging to their lineage groups, the most important of which were fishing areas, hunting districts, homes, and costly heirlooms such as blankets and carvings. Because of their wealth and power they were the only people who could initiate such undertakings as the building of a new house or the financing of a totem pole.

The middle class or common people worked for their house and lineage heads and owned little property of economic importance. Since control of all natural resources was in the hands of the hereditary upper-class leaders, there was little opportunity for commoners to acquire the wealth necessary for expensive and elaborate undertakings.

Ownership of slaves was one of the most decisive hereditary advantages of the nobility. Slaves were captured in raids on neighboring peoples or bought from former owners. Captives and their children after them were slaves. They worked for their wealthy masters and were also chattel property who could be handed over as payment for debt or given away at great feasts or potlatches. Totem poles were often valued in terms of

the number of slaves paid to the various workmen who carved and set up the columns, or in terms of the number of slaves given away or killed at dedication ceremonies.

Indian slavery has of course been abolished. The breakdown of the native culture of the Northwest Coast has also modified other class distinctions, although pride of ancestry and birth is still strong in Tlingit families.

In the latter part of the nineteenth century the mines, fisheries, and other industrial developments introduced by white men gave many natives an opportunity to accumulate new forms of private wealth. Many of the newly rich invested their earnings in carved columns. The dignity of the older symbolic legendary history degenerated in the course of competition for the tallest poles or for the most lavish expenditure at dedicatory feasts.

In the old days every man had some knowledge of woodcraft; he could make hunting gear, fish traps, boxes, and canoes, and he fashioned most of the many tools and implements required in his daily occupations. Every man was potentially an artist, but only the few who were more practiced or more gifted than others became professional carvers. When something as important as a totem pole, house post, or mortuary column was planned, it was one of these artists who was commissioned to do the carving. The desired emblems, and the lineage stories to which they referred, were explained to him. He then designed and supervised the carving, and he himself usually handled the most difficult details. He received large fees for his work.

After the pole was completed the owners gave an elaborate feast, termed a potlatch. Guests from other villages were invited, and the pole was set up and dedicated in a complex ceremonial. During the potlatch the owners recounted the tales symbolized in the carvings. The tales were not mere narratives. They were often presented in dramatic form by costumed actors

7

who dramatized, danced, and sang parts of the stories. Guests were entertained, feasted, and presented with gifts because of their presence and part in the dedication.

Once a carving was set in place it was seldom kept in repair. If, however, the owners desired to repair or move it, they were required by custom to hire specialists to do the work, and they had to rededicate the pole at another potlatch. Since this was expensive and brought them no particular renown, they usually preferred to carve a new column.

Northwest Coast wood carving is today almost a lost art. Posts for the inside of a house have not been made since frame structures replaced the old cedar-plank houses late in the nineteenth century, but the carving of mortuary columns and totem poles continued in some villages until as late as 1905. A very few are even more recent.

Wherever the Indians deserted their old townsites, poles and houses were abandoned to the mercy of weather and vandals. As a result, they were on the verge of disappearing completely when the U. S. Forest Service program of reconstruction was launched in 1938. About two hundred poles were then salvaged —approximately a third of those known to have been standing at the end of the last century.

One hundred and twenty-five poles were counted by a visitor to the deserted town of Tuxekan in 1916. Only sixty were found when Civilian Conservation Corps workers went there in 1939 to remove them to Klawak. Fewer than half of these were sufficiently preserved to identify or move. Many are known to have been sold to dealers and collectors; others were stolen; still others were turned into shapeless, moldering ruins by the moist air and by the luxuriant vegetation that gains a rapid foothold in this rainy coastal area.

Careful checking of the age of carved poles reveals that few have stood longer than seventy-five years, while only a very small number may be as much as a hundred years old. Several

that are known to have been carved in the 1880's are now so badly rotted that they are beyond repair. House posts are usually in better condition than totem or mortuary poles because they were left inside the old houses and thus were protected from the weather until the buildings fell down around them.

The Indians of this region did not develop any wood preservatives, but they did use the highly rot-resistant western red cedar for totem-pole construction. In the early period, native artisans used pigments only to emphasize details of eyes, ears, and other formal designs. Sometimes the designs were merely painted on without being carved. The gaudily decorated and brightly painted poles that can now be seen in shops, parks, and some Indian villages are modern innovations; they are samples of an inferior though often effective style for which Caucasians are responsible. While these modern pieces do catch the eye, they lack the more subtle appeal of the texture of evenly adzed wood weathered to the tint of rich pewter in the sunlight and blending with the purple and grey of lichens in the rain.

The native pigments available before the time of commercial paints were from mineral sources. Ochre furnished various shades of red, brown, and yellow; a copper-impregnated clay yielded a highly prized bluish-green; and manganese derivatives and graphite provided black. Occasionally white, obtained from baked clam shells, was also used. These were the only colors. On many of the poles carved in the last century commercial paint was used to supplement the older kinds of pigment. However, the custom has persisted of using color only for emphasis of portions of the pole.

In the Forest Service reconstruction program commercial paints were used exclusively because of the difficulty of securing and preparing native pigments for a project of this magnitude. The native colors were adhered to as closely as possible, and the artistic native style of decoration was followed strictly. A special colorless preservative was used on the poles to protect them

from weathering. In fact, every effort was made to secure accurate reproduction of the old poles in every detail. Because of deterioration of many poles, questions concerning authentic restoration constantly arose. These were referred to older natives, and their decision was followed. Native tools were used for carving and finishing of the poles; thus it was possible to retain the original type and texture of workmanship. These tools are modern adaptations of the ancient adzes, knives, and chisels. When metal became available the natives began to adapt it to their customary tools and work habits. Knife blades were reshaped and sharpened for workers accustomed to cut toward, not away from themselves, and adze blades were fashioned to conform to the sizes and shapes of older stone blades. Much of the work on the project was done with steel adzes of various sizes, and most of the knives were two-edged to permit carvers to cut both toward and away from themselves. Axes saved much time in the roughing-in of figures, and standard chisels were used for some of the detail carving.

Only a few of the men who worked on the project had had any previous carving experience, though most of them had worked on houses and boats and were therefore familiar with woodworking tools. One of the most experienced was John Wallace of Hydaburg, about eighty years of age, who, as a boy, had assisted his famous artist-father. Later he became a lay church worker and renounced the career his father had planned for him. He encouraged his people to destroy their fine carvings and helped cut down and burn totem poles in Klinkwan. Older and no longer active, he again turned to carving and was selected to attend the International Exposition in San Francisco in 1939 as one of the craftsmen demonstrating native arts. He was head carver at the Hydaburg workshop for the totem-pole project. A painting of his, symbolizing a Haida legend, was included in a traveling exhibit of modern Indian art, sent out by the Museum of Modern Art in New York City.

10

Charles Brown, head carver at the Saxman workshop, and his father had their own boat-building plant. Though he had done no carving previously, Charles Brown became greatly interested and designed two poles for the model village at Mud Bight. His father had built canoes and was a painstaking workman. He produced the deftly adzed surfaces and the detail carving on many of the poles at Saxman. Walter Kita of Klawak was another of the older men who had had experience with woodworking in the native tradition.

The carving tools and even the symbolic figures were completely strange to many of the young men, for they had never seen the poles until they were sent to bring them in for restoration. A few of them acquired some knowledge of their own legends and art for the first time and were eager to learn the techniques of native carving. Others were neither curious nor interested, did as they were told, and asked no questions.

One of the experienced carvers described the procedure of two teen-age boys who came to work in the shop. Neither had handled an adze before. He assigned them to repair the two wolf poles (Figs. 3 and 4). The boys spent a whole day fitting the broken parts together and studying the places to be repaired. Then they practiced with the adzes, the older carvers occasionally offering suggestions. Finally they cut and fitted the necessary pieces, carefully adzing them to the contours of the figures. The older man explained that the boys would make good carvers because they studied and planned before they started to work with their tools.

It is no simple task to record the history of each pole, or to ascertain and note down with accuracy the legends that are so abstractly symbolized. Many of the poles that can still be seen are from long-deserted village sites. Some of the survivors of lineages that used to live in these villages had not seen the poles until the government's reconstruction project was started. Potlatches at which these survivors would have heard the pole his-

11

tories and legends reviewed have not been given for many years. In some instances no member of the clan or lineage which owns a pole could be located, and nonmembers were sometimes reluctant to explain carvings of tales that are not their hereditary property. Some of the figures on the poles constitute symbolic reminders of quarrels, murders, debts, and other unpleasant occurrences about which the Indians prefer to remain silent.

The most widely known tales, like those of the exploits of Raven and of Kats who married the bear woman, are familiar to almost every native of the area. Carvings which symbolize these tales are sufficiently conventionalized to be readily recognizable even by persons whose lineage did not recount them as their own legendary history. On the other hand, carvings like that of the Pointing Figure (Fig. 14) symbolize personal experiences that are known only to a very few.

Local groups have come to regard certain versions of widely known tales as peculiarly theirs, though variations of detail are often slight. In formal storytelling the raconteur was held to the structure of the local version, though stories were not learned word for word as rituals were. There was much greater flexibility in the selection of incidents and elaboration of them for dances and dramas and for explaining the many heirlooms, such as dishes, blankets, headdresses, and masks.

The most complete and best-told versions as judged by the Tlingit themselves were selected for this publication. Minor additions have been made to clarify references to Tlingit customs. The Tlingit phrasing and narrative style have been followed as closely as possible in an English translation.

It is the hope of the writers that the following data will contribute to a better understanding and appreciation of the unique art of the Tlingit Indians of Alaska.

SAXMAN
TOTEM PARK

SAXMAN, three miles south of Ketchikan, on Tongass Narrows, was chosen as the site for the spectacular collection of Tlingit carvings from abandoned towns and cemeteries of Tongass, Cat, Village, and Pennock Islands and Cape Fox Village. Many of the inhabitants of the old towns and their descendants live at Saxman, and the park is in the center of the townsite. The park may be seen from ships approaching Ketchikan and is easily reached from town. It provides a unique opportunity for visitors to see and study native carvings in a natural setting.

The park was laid out with an approaching driveway bordered with poles and a square area walled with hand-adzed logs ornamented with frog heads. Two stairways lead to the square, one flanked by two massive Raven figures and the other by Bear figures. These symbolize the two phratries of the Tlingit.

The first pole completed for the project was the Sun and Raven carving, located at the entrance to the park.

SUN AND RAVEN
(FIGURE 1)

THREE ADVENTURES of Raven, the Culture Hero, were drawn upon for the carvings on this short mortuary post. At the top is Raven with outspread wings. Around his head is the sun halo. On his breast are three figures, the children of the Sun whom Raven visited during the Deluge. The raven tracks painted on

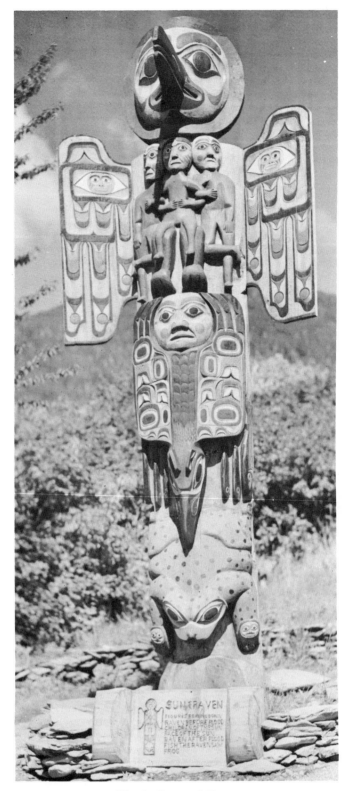

Fig. 1. Sun and Raven

the face of the girl in the center are traditional for women of the Raven phratry. Raven's wings are decorated with eyes, within which are small faces. These symbolize his power to change form and also represent joints. The other designs are feathers.

The story begins with the circumstances of Raven's birth.

A brother and sister were the only people living in a certain place. The brother wanted no one else except his sister and himself, but she was very lonely. One day she walked along the shore and climbed up on a rocky point immediately above a small clear pool. As she sat there crying and thinking how lonely she was, she noticed a small white pebble in the pool below. Still crying, she walked down and got the pebble, which was shaped like an egg. She swallowed it, thinking that it would kill her. After a while she realized that she was to have a child, but did not want her brother to learn of it for fear he would try to kill the baby.

After the child, who was Raven, was born he grew so rapidly that she had difficulty hiding him. She walked along the beach calling for help from the animals of the forest and the birds of the sky. Everything imaginable responded and of each she asked, "What can you do?" She wanted her child to be trained to be strong and brave so her brother could not harm him. Finally Crane answered her pleas, saying, "I'll raise your child." She again asked him, "What can you do?" Crane answered, "I stand in the water winter and summer alike. I will raise your boy that way." She was glad and gave the boy to Crane, who took him down to the beach and out into the cold water every day. Thus the boy grew rapidly into a strong and hardy youth, for that was the way the people in olden times trained their brave men.

When Raven grew up Crane sent him back to his mother. His uncle was very angry and tried to kill him. First he sent him for wood and caused a tree to fall on him. Since Raven was born from a pebble the tree broke over his head and did not harm him. Then his uncle tried other ways to kill Raven, but each time he was outwitted.

Finally the uncle told Raven that he was going to call the tides to come in, meaning that he was going to cause a flood. The water began rising and Raven went out and commanded the tides to stop. Then the uncle commanded them to rise and Raven could not stop them. Realizing that he was beaten by his uncle's stronger powers, Raven went out and shot a bird similar to a sandpiper. He put the bird skin on and flew up into the sky. There he was entertained by Sun. [According to one version he married

15

Sun's daughter and stayed there a long time before venturing to earth again.] He put on the bird skin and flew down, but the waters still covered the earth. He flew until he was tired. Finally he saw a thick cloud and stuck his beak into it. How long he hung there no one knows, but the waters finally receded. Raven prayed for a grassy spot on which to light and then let go of the cloud. He landed safely, removed the bird skin, and was ready for further adventures.

The second episode in the Raven myth cycle is symbolized by the face of Daughter of the Fog, or Fog Woman, the raven head near the bottom of the pole, and the salmon, three on either side of the raven.

Raven was fishing with his two slaves, and was returning to camp when a heavy fog settled over the bay. Suddenly they saw a woman sitting in their canoe. She called for a spruce-root basket, put it on her left side, and began collecting the fog into it. Soon it was bright and sunny and they reached camp.

Shortly afterward Raven went hunting with one of the slaves. Fog Woman dipped her fingers in the stream and immediately salmon appeared. She and the slave with her ate the fish, and she warned him not to tell Raven they had had food. Raven discovered the fact and demanded to know what the slave had eaten. Finally he was told, and he persuaded his wife to produce more salmon, which they dried and stored. They had almost finished when Raven, passing through the smokehouse, caught his hair on a dried fish hanging on the rack. Angrily he pulled it down and, with an oath, threw it into the corner of the smokehouse. Fog Woman immediately left the house and walked toward the beach, and the salmon came to life and followed her. Raven tried to stop her, but she was like fog, and he could not hold her. She walked out to sea.

Raven turned his attention to the salmon but could not save any of them. He and his two slaves were left as poverty-stricken as they were before Fog Woman appeared.

Another version of the story is told in the description of the Johnson pole, located in Ketchikan. (See Fig. 28.)

The third episode from the adventures of Raven is symbolized by the frog at the base of the pole with Raven diving after him.

16

After the Deluge Raven was walking along the shore. He wanted to go to the bottom of the ocean and Frog offered to take him. They saw many strange things, none of which are shown in the carving.

The Sun and Raven pole was carved in the fall of 1902 and placed in the cemetery on the north point of Pennock Island facing Ketchikan. It was made by a famous Tlingit carver, Kahctan, more widely known as Nawiski, for a woman of the Starfish House of the Raven phratry, as a memorial to her two sons. It was repaired and set up in its present location April 11, 1939, as the first pole in Saxman Totem Park.

An older pole belonging to the same house was dedicated at Tongass before the people moved to Ketchikan. It is now in the Ketchikan park. (See Fig. 31.) The one carved for Pennock Island was intended as a copy of the Tongass memorial, but the artist had a shorter pole to start with and had room only for the face of Fog Woman. Her whole figure appears on the older carving.

RAVEN AND FROG
(FIGURE 2)

THE RAVEN poised for flight atop this mortuary column represents the crest of Raven clansmen and also symbolizes two Raven myths. The first is the Deluge myth, and the second is Raven's journey beneath the ocean, both of which are also illustrated on the Sun and Raven pole (see page 14).

The undecorated shaft symbolizes the kelp stem which served as the ladder by which Raven, with Frog as his guide, descended to the floor of the ocean. He visited all the sea creatures and learned many things. When he returned he taught people that sea creatures are just like human beings, described their mode of life, and reported that they had charged him to instruct people how to use foods provided by the sea.

17

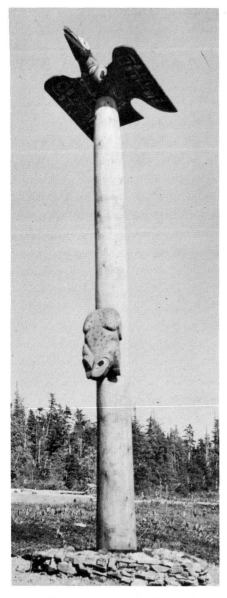

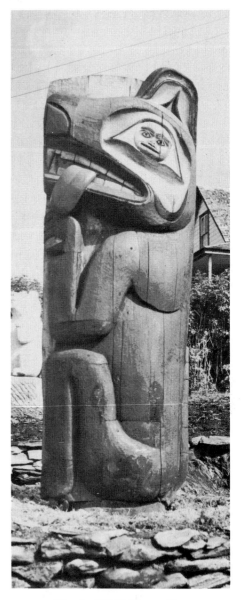

Fig. 2. Raven and Frog Fig. 3. Wolf House Post

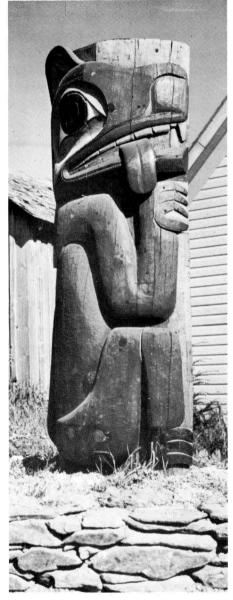

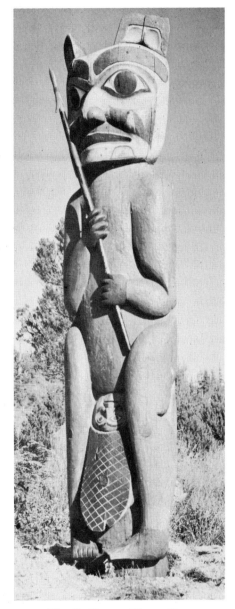

Fig. 4. Wolf House Post *Fig. 5. Beaver House Post*

The original memorial column was set up at Cape Fox in 1894. When removed to Saxman in 1939, it was so badly deteriorated that it could not be repaired, and a replica was made.

TIRED WOLF HOUSE POSTS
(FIGURES 3 AND 4)

AN ENCOUNTER with a wolf is recalled by these carvings.

One day when men of Forest Island House of the Wolf phratry were out fishing they came upon a wolf swimming far from shore. The wolf was so tired that his tongue was hanging out, so the men pulled him aboard their canoe. They took him back to the village, where he stayed with his rescuers. When the men went hunting, the wolf hunted with them and, as he was always successful, they had plenty of meat. He lived among them until his death many years later and came to be regarded almost as a member of the clan.

Not long after his death a dream came to one of the men of Forest Island House in the form of a song. The Wolf people were singing for their dead relative in this dream and they appeared as human beings just like himself. The song follows:

> He did what his forefathers have done.
> He did what his forefathers have done.
> My uncle has crossed the great divide.
> Now I have given up all hope since he is gone.

Because this was a lament for their deceased relative, the people of Forest Island House sing it only as a dirge or mourning song.

The posts were carved on Village Island and installed in a house on Kanagunut Island belonging to the people of Forest Island House. Later they were moved to a new house on Tongass Island. When Tongass was deserted, the posts were taken to Pennock Island, where they marked the grave of Tongass George. They were repaired and set up in their present location in 1939. It is estimated that they were carved about 1827.

Two brothers were hired to make the wolf carvings. The Indians regard the workmanship of one post (Fig. 4) as in-

ferior to that of the other carving. The main difference is in the elaboration of the eyeball into an eye, and the deeper carving of the more admired post (Fig. 3).

This type of profile carving of a figure is quite unusual. Commonly the figures face forward or are carved head downward on the front of the pillar. These are not actual corner posts to be used as a part of the permanent structure of a house, but are mere carved shells to be fastened to the corner post surface facing the interior of the house. For that reason they could easily be moved from one house to another.

It is not always easy to distinguish between symbolic representations of the bear and the wolf. Here the artists added the long, jointed tail of the wolf, removing any possible doubt of his identity. For comparison, note the marble figure of the bear in the background (Fig. 3).

THE BEAVER POSTS
(FIGURES 5 AND 6)

LIKE SO MANY other stories, the one symbolized by the beavers is etiological, explaining how the people of a certain village learned to make a new type of bow and a spearhead that was detachable from the shaft. Originally the story may have been the record of an invention, but, as in many other explanatory tales of the area, the new device is credited to a supernatural being.

Long ago a stranger appeared in the village in Basket Bay. He was treated like a slave. [According to another version he was a slave, bought to serve in the household of the chief.] Every day he disappeared but could be heard singing near the village. The people paid no attention to him.

Every morning large quantities of fish were found outside the doors of the houses. The people noticed that there were neat holes through the sides of each one, so uniform that they wondered who could have shaped the spear points on which they were caught.

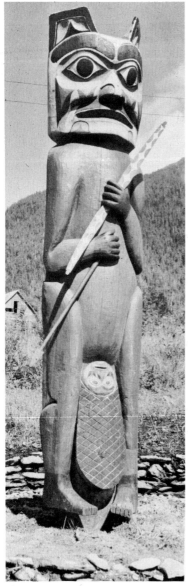

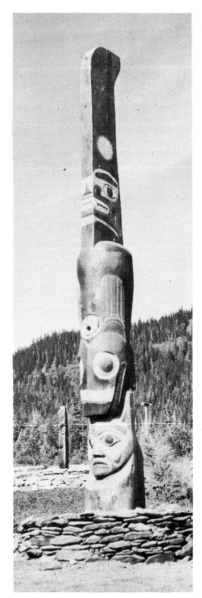

Fig. 6. Beaver House Post *Fig. 7. Blackfish Pole*

Later someone found a bow and arrow in the hills back of the village and brought them in. The bow was so strong that no one could bend it, and the arrow was skillfully made. While the men were gathered round trying the bow, the small stranger came in and said that he would like to try it. They scoffed that anyone as small as he could bend it and threw it disdainfully at his feet.

Beaver picked up the bow and without any effort bent and strung it, sending the arrow swift and sure through the heart of their chief. Then they knew who had killed the fish. Beaver slapped the water with his tail as he ran off, overturning the whole village and killing most of the people. He then disappeared.

The survivors kept his bow and arrow and spear and took the beaver as their crest in memory both of the invention and the disaster that befell their village.

This story belongs to the Basket Bay Tlingit now living at Angoon. A woman from the old Basket Bay village married a Haida and went to live in his town. Her children had the right to the story, including the right to carve the beaver. However, one of them gave it to his Tlingit grandchild, which was unorthodox. The latter was a member of the group that built the house at Tongass and installed the two Beaver posts now in the Saxman Totem Park. The Basket Bay people maintain that the Haida had no right to give the story away, hence the Tongass had no right to carve the beaver.

The paddle-shaped, cross-hatched tail on each carving symbolizes the beaver. The face represents the joint at the base of the tail. One beaver holds the magic spear; the other the powerful bow and arrow.

THE BLACKFISH POLE
(FIGURE 7)

TWO ADVENTURES of the ancestors of people of Blackfish House of the Wolf phratry are illustrated on this carving. The main section symbolizes the blackfish, or killer whale, from which the

23

group takes its name. The long shaft above the body is the dorsal fin. Originally this was undecorated, but when the copy was made the owners granted permission to add the wolf face and the circle. These symbolize a wooden hat owned by the group, on which a wolf face was painted and carved. The small face with open mouth on the front of the carving represents the blow hole of the whale. The legend of the encounter of their ancestors with the blackfish is so ancient that no one knows when or where the event occurred.

Many, many generations ago a group of the Tongass people came upon a blackfish that was stranded on the beach. They saw that the creature was suffering, so they killed him.

That night one of the men dreamed of the blackfish. It was singing, and he awoke and remembered the song, which was as follows:

> I still had faith in myself,
> I still had faith in myself,
> When the tide left me dry.
> But now I give up all hope.
> I wanted to go to the Great Beyond,
> I wanted to go to the Great Beyond,
> Away from death dealt by human hands.
> But now I give up all hope.

The song is a dirge or mourning song, sung only on solemn occasions by members of the Blackfish House.

At the base of the pole is a human face with sharp-pointed wolf ears, which symbolizes another experience of the ancestors of the Blackfish House people.

A man left his village and went into the woods to seek spirit powers according to the old custom. He was gone so long that his relatives gave him up as lost and were planning a memorial service for him. One day they saw him with a pack of wolves. They noted that his ears had grown long and pointed like those of his companions. He was captured and taken home, where he gradually lost the animal habits he had acquired, but he did not lose the skill in hunting taught him by the wolves.

The Blackfish pole is a copy of one that was carved in 1895 and placed in the cemetery on the north point of Pennock

Island. It was dedicated by members of Blackfish House to the memory of a relative.

KLAWAK BLACKFISH FIN
(FIGURE 8)

THIS CARVING symbolizes a mythical monster of the sea about which the southeastern Alaska Indians tell many tales. It has the head and body of a bear and the fins of the blackfish or killer whale. In the carving the dorsal fin is represented as a slender shaft, rounded at the top.

The pole stood in front of a house in the Tongass village on Cat Island. The story and carving belong to a Tlingit group of Klawak, hence its name. It is estimated that this pole was made about 1900, since a photograph of it taken in 1915 or 1916 by the Forest Service shows no signs of deterioration. (Compare with sea monster, Fig. 57.)

THE FROG TREE
(FIGURE 9)

THE LEGEND symbolized in this carving is owned by a number of Tlingit house groups, each of which has its own traditional version. The following version is localized in the vicinity of Cape Fox.

Near an ancient town there was a large lake full of frogs. In the middle of the lake was a swampy place where they gathered on sunny days. One day the chief's daughter picked up a frog in her path and made fun of it, saying, "I wonder if these creatures live like human beings."

When she went out of doors that evening, a young man came to her and asked her to marry him. She had rejected many young men, but she wanted to marry this one right away. Pointing toward the lake, he said, "My father's house is right up here," and the girl followed him. When they reached the house it seemed to the girl as though the door opened for them, but in reality the edge of the lake lifted up, and they walked

25

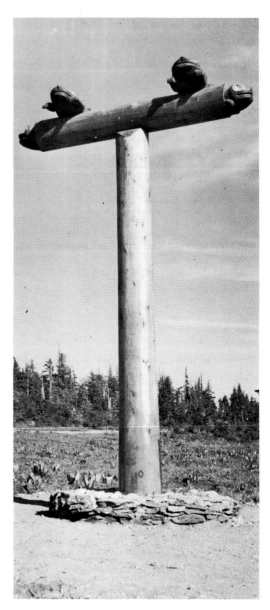

Fig. 8. Klawak Blackfish Fin

Fig. 9. The Frog Tree

under it. So many young people were there that she did not think of her home again. Meanwhile her friends and relatives missed her and hunted everywhere for her. Finally they gave up, and her father had the drums beaten for a death feast.

In the spring a man who was about to go hunting came to the lake to bathe himself as was customary for hunters. When he finished he threw his basket of water on the frogs sunning themselves in the lake. Then he saw that the chief's daughter was among them. He dressed quickly and ran home to tell her father what he had seen. Her parents went to the lake and they too saw her.

Her father and her relatives took all kinds of valuable things to the lake to the frog tribe, but the frogs would not let her return home. Finally her parents decided to drain the lake and rescue her. The frog chief knew what was being planned and prepared his people for their fate.

A trench was dug, and the water flowed out, carrying numbers of frogs who were scattered in every direction. The frog chief asked the woman to beg her people not to kill them. After a while she and her husband floated down the trench on an uprooted tree. Her relatives pulled her out and let her frog husband go. She was covered with frogs.

They took her home and gradually she learned human ways again, but she could not eat human food and soon died.

The Frog Tree or Drifting Log carving was brought from Cape Fox, where it had been dedicated to the memory of a woman of the Kiksetti clan. Her name was Two (Frogs) on a Drifting Log, hence the name of the pole. On the original carving a frog was shown emerging from the center of the upright support, to symbolize the woman emerging from the lake when her relatives came for her.

George Grinnell, who was in the village in 1899, wrote, "Another [pole] which from its appearance seemed to have been standing for very many years—for it was gray with weather, and long strings of lichen hung down from it—consisted of the stout upright twenty feet in height, surmounted by an almost equally stout cross pole, on either end of which sat a large carved toad."[1]

[1] George Bird Grinnell, *The Natives of the Alaska Coast Region.* Harriman Alaska Series, Volume 1, Smithsonian Institution, 1910. Page 147.

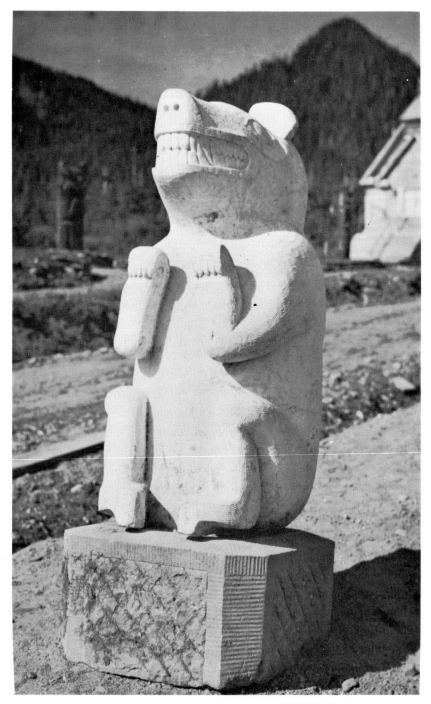

Fig. 10. Grizzly Bear Monument

GRIZZLY BEAR MONUMENT
(FIGURE 10)

WHEN WOOD CARVING began to decline, marble monuments were sometimes used in place of wooden memorial columns. A wooden model of the desired monument was sent to a marble cutter, usually in Victoria or Seattle, and a copy made. Such monuments may be seen in many villages on the Northwest Coast.

The marble grizzly bear exhibits all the characteristics of a conventionalized wood carving, even to knife marks and the stippled pattern left by a finishing adze. A wooden figure of this size would have been mounted on a section of tree trunk six to eight feet high

The grizzly bear is the main emblem of Grizzly Bear House of the Wolf clan, and this monument is the crest of the man whose grave it marked. It does not illustrate any particular legend or historic event, but serves as an identifying symbol or mark.

The monument was set up at Cape Fox by the sisters of the deceased man and removed to Saxman at the request of his descendants.

KATS AND HIS BEAR WIFE
(FIGURE 11)

THIS CARVING was set against the center of the front of the house, framing the entrance. It was used only on special occasions, as there was another door which the family used ordinarily.

The top figure is the grizzly bear woman who became the wife of Kats, who occupies the main section of the pole. The small faces in his ears and nostrils symbolize the keen animal senses developed during his sojourn with the bear. The animal ears,

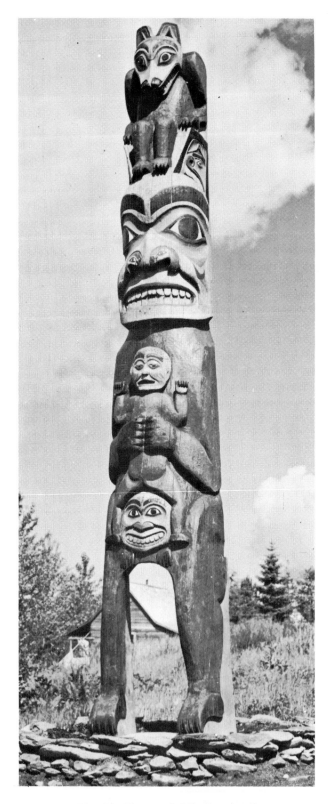

Fig. 11. Kats and His Bear Wife

between which the bear wife sits, show that Kats was no ordinary man but possessed supernatural powers. These two figures symbolize one legend. The opening at the base of the pole, serving as an entrance to the house, also represents the entrance to the bear's den. The two figures above the entrance represent descendants of Kats many generations later.

Long ago on Rudyerd Bay lived a family in which there were four boys. One day Kats, the eldest, took his dogs and went into the woods to hunt grizzly bear. He traveled far up on the mountain, his dogs running on ahead. Suddenly they came upon a den in which two grizzly bears lived. The dogs barked, and the old male bear came out. He grabbed the young man and threw him into the den. As Kats fell he involuntarily reached for something to save himself and touched the she bear. Immediately she was changed [and appeared as a woman to Kats]. She quickly dug a hole in the floor and hid him. When her husband had chased off the dogs he came in and asked where the man was. The she bear answered, "You didn't throw any man in here, you only threw a mitten in." He searched but could find nothing. Angrily he left the den.

When Kats did not return home his younger brothers made plans to search for him. The two next younger brothers left their wives and began purifying themselves by bathing and drinking sea water that their venture might be successful. The youngest brother followed all the rules except that he did not leave his wife, and the older boys criticized him for this.

After many days of fasting and purification the next younger brother was ready. He took Kats's dogs and started out. Soon Kats's bear wife saw something like arrows fly into the den on a beam of sunlight and strike the wall. She said, "Do you see that?" Kats saw only the shaft of sunlight. "Those are your brother's thoughts. He has left the village looking for you. He will never find you because he is not truly sacrificing, he is only pretending." With that she pulled the "arrows" from the wall and threw them outside. All day the second brother hunted up and down the valleys and hills and returned to the village late in the evening without finding any trace of Kats.

After several days of ritual preparation the next brother took the dogs and went to search for his elder brother. Again the "arrows" flew into the den, and again the bear woman threw them out. She told Kats, "He is only pretending to purify himself and he will not find you." The third brother returned home, having failed to find any clues to Kats's whereabouts.

31

The youngest brother paid little attention to the others but continued to drink sea water and stay with his wife. Finally he was ready to take up the search. The other men tried to dissuade him, pointing out that he had not lived up to the rules and would surely meet with disaster. He paid no attention to them, for he knew that his wife had cooperated fully in his ritual preparation and that his power was strong.

As soon as he started, the arrow-like shafts of light again struck the wall of the den. The bear woman told Kats, "Your youngest brother is coming. He has truly sacrificed and prepared himself. You see how his power is imbedded in the wall. I cannot pull it out. He will be here very soon." As she had said, they soon heard the dogs barking in front of the den.

The bear wife instructed Kats to go and meet his brother and tell him what had happened. He went out and spoke to his dogs, and they immediately recognized him and stopped barking. He patted the dogs and spoke to one of them, saying, "Man for the Mountains, you never fail when you go after something, do you?" Then his youngest brother came up, and Kats told him everything that had happened. He told his brother to go home and tell the people that he would come in the spring when the bears came out of their dens.

The family watched constantly for Kats's return, and one day they saw him with his bear wife and cub children coming across the flats toward the village. They stopped, and the bear wife instructed her husband not to look at his human wife or speak to her. Then he went on into the village. Kats and one of his fellow tribesmen hunted seal, which he took to his bear wife and cubs. When his luck was good he brought back two or three. Only then would the bear get some. When there was only one the cubs ate all of it, forgetting their mother.

Because his bear wife was thus mistreated, Kats thought up a scheme to catch fish for her. When summer came, he built a semicircle of rocks in front of a little slough. When the tide came in, the fish were trapped by the rock barrier. In that way he caught plenty of fish for his family.

One day when Kats was returning from seal hunting, his human wife hid behind one of the houses. As he came past she stepped out, and he could not help looking at her. His bear wife immediately knew what had happened. Later he landed in front of her camp as usual, and walked right up to her, though he knew that he had done something she had forbidden. She got up and said, "I told you not to look at that former wife of yours," and with that admonition gave him a gentle shove. She knew he could not prevent it and did not intend to punish him. However, the cubs sprang upon him and tore him to pieces before their mother could save him.

After her husband's death the bear turned around and went up into the hill country. As she walked slowly up the mountain she sang a song of sorrow:

> I wonder where my husband has gone.
> I wonder where my husband has gone.
> He left me.
> He left me.

As she went along, her husband's sealing partner heard her singing. He learned the song and went back to the village and told the people what had happened. Since that time the dirge has been sung by the descendants of Kats, and the post was carved to commemorate his fate. They also took the name, Kats House, by which they and their dwelling have since been known.

The small human figure held by Kats is a descendant of his, a poor orphan who was despised and finally abandoned by his relatives. Below him is his "grandmother." The story of their experiences is the very familiar rags-to-riches theme of Northwest Coast tales.

A small boy lived with his uncle, who was his only relative. His uncle was a chief who had two wives. The elder wife did not like the orphan and urged her husband to move to camp and leave him in the village. The younger wife pitied the boy and often saved choice morsels of food for him. One day the chief decided to move and leave him and an old woman who was too feeble to work.

The chief ordered all the houses taken down, even to the corner posts, and all the fires put out. As they were leaving, the younger wife told the boy that she had hidden some dried fish for him in one of the post holes. When they had left, he and the old woman searched the village and found a live coal with which they built a fire. Then they built themselves a shelter. The old woman made him a bow and arrow with which he was able to get squirrels and birds.

One day he went farther into the woods than usual and saw a young mountain goat, which he killed. He was very happy. He skinned it carefully and put the skin over his shoulders with the forelegs in front. Then he started to dance and soon lost consciousness. When he regained his senses he was far back in the woods. He began to cry and lost consciousness again. When he awoke he was still in the woods. He wandered about,

crying. Many times he lost consciousness. The eighth time this happened, he awoke to find himself high up on the face of a cliff on a narrow ledge. Again he lost consciousness.

In the meantime the old woman, who knew he was receiving his spirit power, fasted and drank sea water to help him. On the eighth day after he disappeared she heard the voice of a shaman coming from the woods back of the village. She was too feeble to go to him, but she built a small shelter at the edge of the woods.

When the boy again came to, he was standing where he had skinned the goat. The skin was over his shoulders and he was dancing; the spirit had come to him. He carried the meat back to the shelter his grandmother had built for him.

Immediately he began to test his shaman's powers. When he hunted for birds and squirrels they died at his feet. Later he hunted larger animals, and they too came to him. His grandmother dried and smoked the meat, and they stored it in their shelter until it was full. Then the boy told her to build a tiny house, which she set in a cleared level spot. Then he stood in front of it and with the aid of his spirit powers expanded it into a fine, large community house. This too they filled with smoked meat.

In the meantime the chief decided to send slaves back to the village to bury the boy and the old woman, for he believed they had starved to death. Through his shaman's powers the boy knew his uncle's plans. When a slave and his wife and baby arrived they were kindly treated and given food. The slaves marveled at the stores of meat and told the boy that the chief and his people were starving. They were warned not to tell the chief that the boy and old woman were alive and not to take any food with them. The slave woman knew that her baby was hungry, so she hid a piece of seal fat in her blanket.

When the slaves returned to camp they told the chief that the boy and woman were dead and that they had buried them as directed.

During the night the slave baby began to cry and woke the chief, who sent one of his young men to investigate. He found that the baby had a piece of blubber and called the chief. The slaves then had to tell him the true story. They described the great stores of food, enough to feed the whole camp. That same night the chief gave orders to break camp and return to the village.

Before they rounded the last point, the elder wife washed her face and painted it. The boy knew what was taking place, and when the elder wife took a piece of shredded cedar bark to wipe her face, he caused a piece of flint to cut her. The younger wife did not paint her face, for she knew that

she had been kind to the boy and she felt that he would remember her kindness.

When the canoes arrived in front of the village, the boy called for his uncle's younger wife to come ashore. He then told the chief that he would be chief instead. The elder wife begged to come ashore, but the boy told her. "No, you and that slave who was once my uncle will both be slaves of mine if you wish to eat. You never treated me kindly when I was a poor orphan in your house."

The boy took his uncle's younger wife for his own wife. He exchanged food for the possessions of the starving townspeople and became a very rich man.

One day he called the people. When they were all in his house he asked, "Which one of you will stay with me to the finish?" Finally he called the old woman to him. He took a bone and wrapped her hair around it and told her to sit by the drum, giving her the bone for a drum stick. He said, "When you are crowded away and cannot reach the drum, just nod your head."

The old woman began to beat the drum and he danced. Soon the people heard a noise far back in the woods coming closer and closer. Then they recognized the grunts and growls of grizzly bears and they all ran out and hid as the bears crowded into the house. Soon there were so many that the old woman was not able to beat the drum. She nodded her head toward it and the drum continued to beat while the shaman danced. Soon the spirit powers began to leave the boy and the grizzly bears began to drop over dead. When all his powers had left him, every bear was dead.

It is said that the grizzly bears were the descendants of the cubs born to Kats and his bear wife and that they were killed by the shaman's powers.

The Grizzly Bear post belongs to people of Kats House of the Tongass tribe. It is approximately one hundred years old and was brought from Village Island to Saxman in 1939 to be incorporated in the totem park. According to legend this is the fourth pole of its kind carved to commemorate the experiences of Kats. The first one was carved by Tongass people living near Unuk River on Behm Canal. From there they moved to Cape Muzon, and the second post was set in front of the Kats House there. Later some of the Kats House people moved again, settling in the vicinity of Hydaburg, where the third post was

Fig. 12. The Loon Tree *Fig. 13. Owl Memorial*

carved. This was before the Haida migration to Prince of Wales Island, more than two hundred years ago. Members of the house again migrated, settling at Tongass and at Village Island, where the present post was carved. When the Tlingit moved to Saxman, frame structures were built, and the carving belonging to the plank community house was left behind.

In Ketchikan Park is another Kats pole, symbolizing the same story (Fig. 31). When the people moved to Tongass, two brothers separated, and each built a house of which he became the head or chief. One carved the above post to commemorate the legend of their origin, while the other kept the original entrance pole. Carvings on a pole (Fig. 12) belonging to another branch of the Kats House people and now at Saxman Totem Park also illustrate the same story.

THE LOON TREE
(FIGURE 12)

THE LOON surmounting the pole symbolizes the experiences of ancestors of the Kats House people.

Long, long ago they were living far up Shrimp Bay on Behm Canal. It became dark. [It may have been an eclipse, or, according to another version, this occurred before Raven brought daylight.] The people could not find their way out of the bay. They heard a loon whistling and followed the sound until they located the bird, which then swam in front of their canoes and led them out into daylight. Since that time the loon has been the special emblem or crest of their descendants.

Below the loon are three bear cubs and, at the bottom of the pole, the bear wife holding her human husband, Kats. These figures symbolize the adventures of Kats, described above.

The original of this pole was brought from Cape Fox Village and copied at the Saxman workshop. The carving of the original was done by four different artists, of whom three were Tlingit and the fourth a Haida. The latter artist carved Kats and his

37

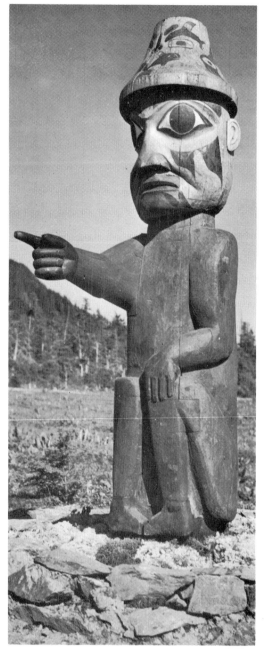

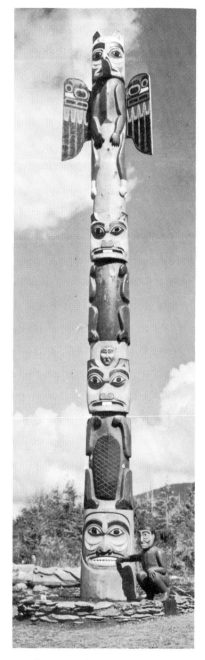

Fig. 14. Pointing Figure

Fig. 15. Giant Rock Oyster
Memorial

bear wife and the bear cub immediately above them. The grooves in the ears of the bear wife are characteristic of Haida carving and would not be used by a Tlingit. The slender body and flattened snout of the bear cub also conform to Haida style. Each of the Tlingit carvers was assigned one of the three upper figures as his contribution. The copy lacks the individuality of the original, on which each bear cub was a distinct personality.

OWL MEMORIAL
(FIGURE 13)

THE OWL at the top of the pole was the main crest of the medicine man, or shaman, in whose memory the carving was dedicated. The owl crest is explained by the legend of a woman who disappeared from the village after an altercation with her mother-in-law. She turned into an owl, and her relatives took it as their crest or emblem. People can understand the cries of an owl because it was once a woman.

At the base of the pole is weasel, one of the chief aides of the shaman. Whenever he wanted to perform magic or discover the cause of an illness, the shaman called upon his spirit aides, who gave him information and told him what to do.

Since weasel is not a crest, but the property of a very few powerful shamans, it is seldom carved on poles. Were it not for the white body and black-tipped tail, it could easily be mistaken for a wolf. The two tiny faces symbolize spirits and emphasize the supernatural character of owl and weasel.

POINTING FIGURE
(FIGURE 14)

THIS FIGURE is probably the portrait of a man wearing a wooden hat. The human ears and well-carved features show that the artist had some real person in mind and was not trying

to portray a being with human-supernatural characteristics. The significance of the figure could not be ascertained beyond the fact that it symbolizes an experience of some ancestor of the owners with a spirit power or aide. The general opinion was that he had been a shaman. It is one of the carvings the meaning of which was known to only a very few people.

The carving was made for a group of brothers belonging to Raven Bone House of the Raven clan and set up sometime between 1890 and 1900 to mark the grave of their sister on Pennock Island. It was originally placed on top of a short, undecorated shaft.

An earlier Pointing Figure was set up on Cat Island by ancestors of the same group for a deceased relative. Andy Moses, who helped with the carving of this memorial, commented that he had never inquired into the story explaining it, since he was a young man and, like many young men, not interested in such matters.

GIANT ROCK OYSTER POLE
(FIGURE 15)

ON THIS POLE are carved the emblems of four related house groups of the Nexadi clan, descendants of Eagle Claw House, whose crest appears at the top of the pole. The human body with claws instead of feet symbolizes the members of Eagle Claw House as distinct from other Eagle clansmen.

The beaver below the eagle is the crest of Beaver Dam House, while the second beaver is the emblem of Beaver Tail House. The face at the base of the pole symbolizes Giant Rock Oyster House. All three of these house groups are offshoots or subdivisions of the parent Eagle Claw House. This pole is a kind of genealogical record of the relationship of the four house groups to each other and was dedicated as a memorial to deceased members.

40

The man whose hand is caught in the oyster recalls the tragedy that gave his relatives their name.

Many years ago there was a Tlingit village at Kasaan Bay. One day several men went to a reef at the north end of the village at low tide to hunt devilfish. Soon a young man located one of them under a rock. Taking his long-handled hook, he poked it into the hiding place and hooked the fish, but it tore loose and moved out of reach. The man dug around the rock with a stick and finally put his hand into the crevice, though his companions cautioned him against it. As he reached under the rock, a giant rock oyster caught him by the wrist.

His companions could not extricate him, so they sent to the village for help. They tried to pry the oyster open, but the shells only closed more tightly. The boulder was too heavy to lift, and efforts to turn it over failed. It only sank deeper into the sand, pinning the unfortunate victim beneath it. As they frantically worked to free him, the tide rose higher and higher. When it reached the victim's shoulders, he began to sing:

> Where is the tide, where is the tide?
> Watch for thyself, watch for thyself.
> Oh, spirits of tide, they are coming up.
> Oh, spirits of tide, they are coming up.
> Oh, sons of tide spirit, they are coming up.

The tide reached his shoulders, but the imprisoned man continued to sing. The water covered him completely, and he was dead.

When the tide fell, his relatives found his body on the beach. The giant oyster had let him go. The song he composed was sung at his funeral, and since that time it has been owned by his descendants. They also took Giant Rock Oyster as the name for their house.

There is a long and interesting story connected with the members of Eagle Claw House, represented by the topmost figure on the pole. It is called "The Young Man Who Fed Eagles" and is localized near Port Simpson, British Columbia. The story was probably acquired from the Tsimshian through intermarriage.

South of Port Simpson, at the mouth of a small bay, is a very long reef. The village was located back of this reef near a fine salmon stream where the people secured their winter supply.

THE WOLF AND THE RAVEN

Living in the village was a young man who did nothing to help get food for the winter. He speared salmon and took them to the reef for the eagles. This he did every day, though his relatives scolded him and urged him to help them. They asked, "Why do you feed those eagles? They will not feed you when the cold winter comes." He paid no attention to them.

Winter came, and the boy was often hungry, for his relatives would give him no food. Going from house to house, he was told to go to the eagles and they would feed him. Only his uncle's old wife pitied him and gave him food when no one was looking. This she continued to do all winter until March, when it was time for the people to move to the Nass River to fish for eulachon. [These small fish were caught in large numbers and made into oil used by the Indians in many of their favorite dishes.] When the canoes were ready to leave, no one would take the boy or the old woman who had fed him. The chief ordered that no food should be left for them and that all the fires in the houses should be extinguished. However, the old woman hid a coal in a clam shell and managed to hide a little dried fish.

Having gone to bed one night very hungry, the boy awoke from a troubled sleep. He thought he heard an eagle screeching as though it had found or killed something. The boy walked out on the reef and found a fish there. It did not occur to him that the eagles had brought it; he thought that it had drifted there.

The next day he again heard the eagle screech and went to the reef. This time he found a still larger fish with eagle-claw marks on it. Each day thereafter he heard the eagle's call and found many kinds of food on the reef. There were halibut, king salmon, seals, sea lions, whales, and many other sea foods. All these he and the old woman stored away, filling many cedar storage boxes with dried food.

In the meantime those who had gone to the Nass were starving, for the eulachon run was late. The chief began to think of the boy and the old woman left in the village. He sent a slave with his wife and child to see if they had starved to death.

When the slaves arrived the boy invited them to the largest house in the village and gave them all kinds of food to eat. He instructed them not to take any food with them but to tell the chief, his uncle, that he was alive. However, the slave woman hid a piece of seal blubber under her blanket. Then they set out for the Nass. They told the chief that the boy and the old woman were still alive but did not mention the stores of food.

One night when the slave woman's baby was crying she gave it the piece of blubber. The baby choked on it and the chief's wife told them to

bring the baby to her. She put her finger down the baby's throat and brought out the piece of meat. The slaves then told the chief what had really happened and how well the boy was prospering.

When the chief learned of this he ordered everyone to pack up and return to the village. He dressed his younger daughters in fine clothes and ornaments of abalone and copper, but his elder daughter was not attractive, so she wore her old clothes. When they arrived in front of the village, some of the people were so hungry that they cupped their hands and drank the oil that floated out to sea from the many fish and animals the young man had left on the beach. Only the elder daughter sat quietly in the canoe and did not eat the offal on the water.

Though his uncles begged him for food, the boy would not allow them to come ashore until they had promised to give him all their belongings in return. He became a very wealthy man, was chosen a chief, and married his cousin who had not stooped to eat offal even when she was starving.

This pole was brought from Cape Fox in 1938, where it stood in front of the Eagle Claw House. Two very unusual carved corner posts from this house were brought to the Saxman workshop for preservation. Each was carved to represent the foreleg of the eagle with the "knee" resting on the ground and the claws supporting the end of a house beam.[2] Most carved house posts are flat or hollow at the back, and the decoration occurs only on the section of the post that would be visible inside the house. These eagle-leg posts are, however, carved in the round. The selection of the leg as a design is also very unusual, for in the great majority of carvings the whole body was used, even though distorted and rearranged to conform to the highly formalized conventions of the art style.

MEMORIALS OF EAGLE TAIL HOUSE
(FIGURES 16, 17, 18, 19, 20, 21)

THE THREE COLUMNS, each with an eagle on top and a beaver at the base (Figs. 16, 17, 18) commemorate members of Eagle

[2] T. T. Waterman, *Observations among the Ancient Indian Monuments of Southeastern Alaska*. Smithsonian Miscellaneous Collections, Volume 74, Number 5, 1923. Figure 114.

Tail House of the Nexadi clan, a group closely related to the owners of the Giant Rock Oyster pole (Fig. 15).

The Nexadi were once a part of the Kagwantan living in the vicinity of Kuiu Island. For some reason now unknown, a small group moved south, stopping for a time in Kasaan Bay, above New Kasaan. Some of them again moved southward, stopping at a bay called Nahgath or Nakat. This group took a new name from the bay and became known as Nexadi or Nakat Bay People, though they continued to claim the eagle of their ancestors as their main crest. After many years they settled at Cape Fox Village near Kirk Point. All of the people who lived there—of whom the Nexadi were only one group—became known as the Cape Fox tribe.

One group of Nexadi built a large community house, which they named Eagle Tail House. Kashakes was the head of this house. As the group increased in numbers, other dwellings were built. These houses were named Eagle Claw (or Leg), Beaver Dam, Giant Rock Oyster, Halibut, Small Eagle Claw, Eagle, and Yeash. In the latter part of the nineteenth century, members of all these houses moved to Saxman, where they built new community dwellings. The Halibut House people ornamented the front of their home, built about 1889, with a painting of the halibut (see Fig. 19). It was the only house in Saxman so decorated. The home of the present Kashakes is the only community house remaining in the village. A painting of an eagle tail on a large cedar board originally adorned the front but has since been removed.

The three eagle and beaver poles were brought to Pennock Island when the people moved to Saxman. One of them was dedicated to the memory of Kashakes' sister and was carved about 1875. They all symbolize the relationship between Eagle Tail House and Beaver House people.

There is an interesting variation in the posture of the eagles; one sits quietly in a tree top, one is poised for flight, and the

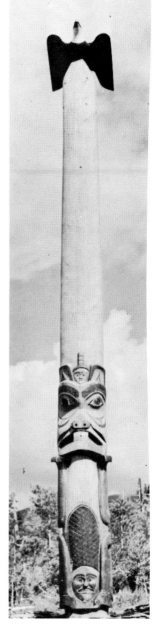

| Fig. 16. | Fig. 17. | Fig. 18. |
| Eagle and Beaver | Eagle and Beaver | Eagle and Beaver |

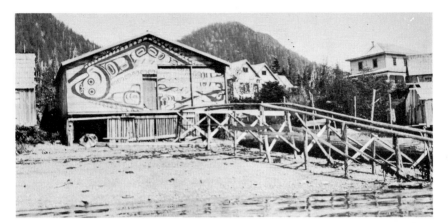

Fig. 19. Halibut House

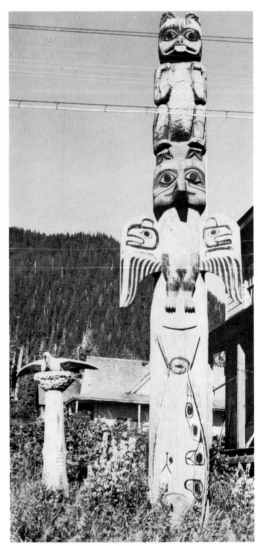

Fig. 20. Beaver House Memorials

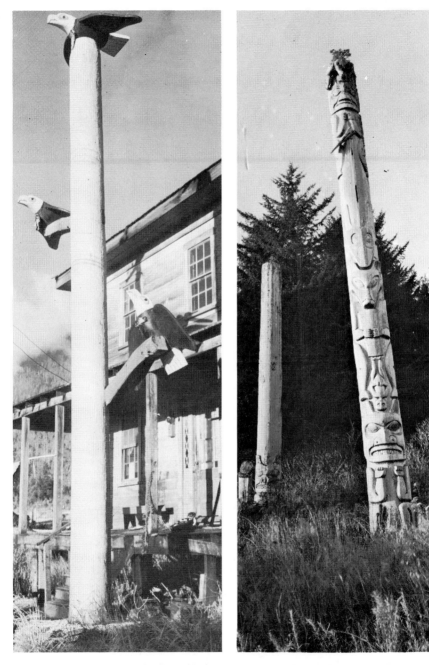

Fig. 21. Three Eagles *Fig. 22. Dogfish Pole at Tongass*

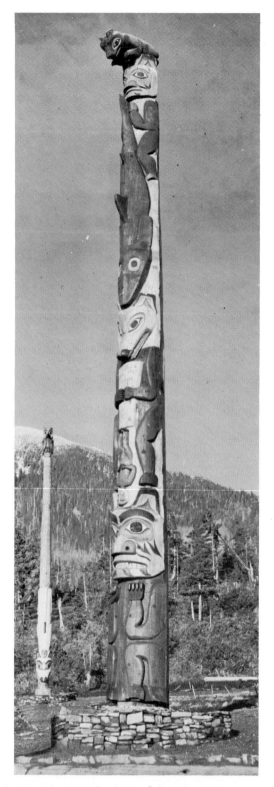

Fig. 23. Repaired Dogfish Pole at Saxman

third seems as though screeching defiance from its mountain eyrie. The beaver carvings show such slight variation that they appear to be the work of a single carver. The face on the tail of one of them is the customary symbol of a joint, and the small face between the ears of the same figure is that of a man wearing a woven spruce-root hat. The two extra sections represent separately woven rings fastened to the crown of a ceremonial hat such as was worn in dancing.

Three other memorials stand in front of Kashakes' house a short distance south of Totem Park. The marble monument in the background (Fig. 20) symbolizes the name of the woman, Eagle Sitting on a Nest, in whose memory it was dedicated. Below is a log or tree scored with beaver teeth marks, and at the base, obscured by grass, is the beaver, symbolizing the house group or lineage to which she belonged. The beaver at the top of the wooden memorial honors members of the same group. Here the eagle is placed below the beaver. At the base is a halibut.

The carving of three eagles in a tree (Fig. 21) was made in 1939 in memory of three of Kashakes' nephews. It also symbolizes a hereditary personal name, Eagles Sitting in a Tree One above the Other, which is always held by a leading man in the lineage. It is obvious that the carver of this memorial departed completely from the traditional form and style of Tlingit mortuary columns.

DOGFISH POLE
(FIGURES 22, 23)

SURMOUNTING THE POLE is a bear, one of the main crests of the Wolf clansmen who owned it. Below is one of the clan members holding the tail of a dogfish or mud shark, also a crest of the group.

The wolf with animal head and human body symbolizes Wolf clan members. He holds a carved replica of one of the ancient hammered-copper plaques or shields which were held in high esteem. Every wealthy man aspired to ownership of at least one, as it represented from one to three thousand blankets or fifteen to twenty slaves in exchange value. Each shield was named, and each increased in value when it was bought and passed into the hands of a new owner. Occasionally a copper shield was nailed to the mortuary column of the deceased owner.

On the plaque is an inscription giving one of the few precise datings for carved poles: "In Memory of Ebbits, Head Chief of Tongass, January 11, 1892." Eliza Scidmore, writing of Tongass in 1893, says, "A tablet on one house reads, 'To the memory of Ebbits, head chief of the Tongass, who died in 1880, aged 100 years.' Two fine totem poles also record the honors of this Neakoot, who assumed the name of John Jacob Astor's Captain Ebbetts as a compliment to that trader."[3] Captain Ebbetts visited southeastern Alaska in 1802 and again in 1809. According to tradition, he was entertained by a wealthy Tongass house head, and the two men exchanged courtesies and gifts and sealed their friendship by an exchange of names. Since then Ebbits has been the hereditary name of the Tongass house head. The two poles mentioned by Mrs. Scidmore have not been identified, though one of them may be the Dogfish pole.

The human figure carved head downward is a public record of a debt owed to Ebbits and his heirs, the nature of which was not learned. At the base of the pole is another bear, symbolizing the members of the clan who claim that crest.

The contrast in appearance between an unpainted and a painted pole is very clear in these two photographs. The pole photographed in the abandoned village had weathered to a silver grey, and every vestige of the original paint was gone.

[3] Elizah Ruhamah Scidmore, *Appleton's Guide-book to Alaska and the Northwest.* New York, Appleton, 1893. Page 52.

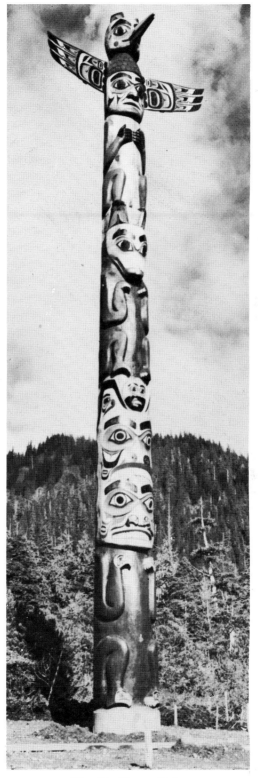

Fig. 24. Raven Pole

The top of the bear had rotted off, and a spruce tree had gained a foothold in the moist wood. To restore the pole, a new bear was carved and the tail and fins of the dogfish were replaced. Minor patching and repainting completed the restoration.

The carving is very shallow, and the figures have a flat look that is not found in earlier work. However, the Tlingit admire the fine, even adzing of the surface of the dogfish, done by a noted Tsimshian artist. Weathering has partly obliterated the original surface. This is one of the last totem poles set up at Tongass and marks the degenerative period of the carver's art.

RAVEN POLE
(FIGURE 24)

RAVEN ON THE TOP of this pole is carved with outspread wings ornamented with feather and wing-tip designs, and with breast feathers forming the hair or headdress of the human figure below. This is an arrangement similar to that of Raven and Fog Woman on the Kadjuk pole (Fig. 28).

Below is a bear and beneath that two supernatural beings. Of the upper one appears only the head, its teeth encircling the forehead of the lower figure. Small faces in the ears and nostrils and on the feet of the two lower figures emphasize their supernatural character. The carving of these figures is very similar in style to that of the lower part of the Dogfish pole (Fig. 23). Like the latter, this carving dates from the end of the nineteenth century and is a poor sculpture.

PRESIDENT LINCOLN
(FIGURES 25, 26)

ONE OF THE most interesting likenesses ever made of the Great Emancipator is the sculptured figure atop this totem pole. Tow-

52

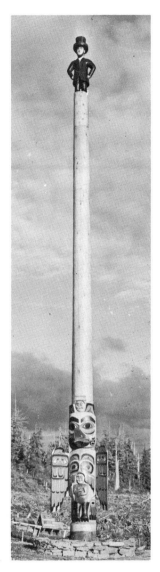

Fig. 25. Lincoln Figure
from Original Pole

Fig. 26. Copy of Lincoln Pole

ering far above the crest at the base of the pole, he is given the place of honor even above the Tlingit's own emblems. The pole commemorated the cessation of hostilities between two Tlingit villages and was symbolic of the peace and prosperity they hoped would follow American occupation of the Territory.

In the spring of 1868 a customs house and fort were built on Tongass Island. A company of soldiers and the revenue cutter *Lincoln* were assigned to the post to patrol the area and to enforce law and order.

Just previous to this date the Kagwantan, one of the powerful clans of the Eagle phratry, and the Tongass Ravens were engaged in raiding and enslaving each other. The Kagwantan were determined to destroy the Tongass Ravens and continually harassed them, taking captives, burning towns, and murdering women and children. The Tongass were driven from their homes and from one refuge to another. Finally they entrenched themselves in a log fortress on Village Island, a low sandy island in Clarence Strait. There was no water on the island and very little food, but the besieged Tongass were temporarily safe because of the difficulty of approach to their stronghold. The Kagwantan settled down to wait, believing their enemies would have to surrender or starve.

One night a messenger arrived informing the Tongass of the presence of the soldiers and the revenue cutter. Realizing that they would be protected, they watched their chance and fled to the station, settling on the beach adjoining the parade ground under the shelter of the guns of the *Lincoln*. There they made peace with the Kagwantan, and the two groups have not been at war since.

To commemorate the protection they received, the Tongass sponsored the carving of the Lincoln pole. Chief Ebbits is said to have initiated the undertaking, in which two subchiefs, Tsakad and Haiyaw, took an active part, assisted by several wealthy headmen.

A Tsimshian artist from Port Simpson, British Columbia, by the name of Thleda was hired to do the carving. At the base is an excellent raven figure, called Proud Raven, honoring the Tongass Ravens who outwitted the Kagwantan and forced them into a peace pact. The pole is generally known to the Tlingit as the Proud Raven pole. Thleda was given a picture of President Lincoln to copy for the top of the column.

As may be seen from the photograph (Fig. 25), the Lincoln sculpture was in poor condition when the pole was brought to Saxman in 1938. A copy was made for the totem park, and the original was sent to the Territorial Museum in Juneau. Time and the elements have not obliterated the finely chiseled features or the careful attention to detail. Though native artists were not often called upon to carve naturalistic likenesses of real people, portrait masks and miniature figures collected from the area prove that they were thoroughly capable of such portraiture.

Though it has been impossible to establish the exact year it was dedicated, the carving of President Lincoln was raised over Tongass Village in the late 1870's or the early 1880's, ten to fifteen years after the events it commemorated.[4]

SECRETARY OF STATE POLE
(FIGURE 27)

STANDING NEAR the carving of President Lincoln in Tongass Village was the figure of his Secretary of State, William H. Seward. Seward, perhaps more than any other one person, was responsible for the purchase of Alaska from Russia.

In the summer of 1869 Seward visited the Territory and stopped at Fort Tongass. While there he was entertained by Chief Ebbits, who spread luxurious furs for him to walk on.

[4] James Wickersham, "The Oldest and Rarest Lincoln Statue." *Sunset Magazine,* February 1934.

A handsomely carved and painted chest covered with furs was his seat of honor, and Ebbits presented him with an ornamented hat, the furs and chest, and other gifts.

Some years later, probably about 1885, the Seward pole was carved to commemorate the visit. The Secretary of State is shown sitting on the carved chest, wearing the spruce-root hat with ringed crown that is the mark of an influential and wealthy man. According to tradition Seward did not repay either the courtesy or the generosity of his hosts, and the pole served to remind the Tongass people of the fact. No crest or other symbolic carvings were added to the slender shaft on which Seward sat for so many years above the deserted village.

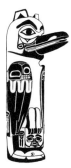

KETCHIKAN
TOTEM PARK

CIVIC-MINDED individuals and organizations of Ketchikan, realizing the value of native art and the interest of visitors in it, purchased a number of poles which have been placed in the city park and kept in repair. Unfortunately, they have been painted in vivid colors that do not correspond to the color range of native pigments. They also violate the native artistic convention of using paint only for emphasis of detail. Assistance has also been given to preserve the Johnson pole, the only one in Ketchikan still standing on the spot where it was originally erected and dedicated.

CHIEF JOHNSON'S POLE
(FIGURES 28, 29)

AT THE INTERSECTION of Mission and Stedman Streets in Ketchikan stands the Chief Johnson pole, called by the natives the Kadjuk pole. It belongs to the Kadjuk House of the Raven clan, and was carved and set up in its present location in 1901 by the head of the group, known as Chief Johnson. Behind the pole a community house was later built, on the front of which was painted a whale, the crest of the group (Fig. 29). The house burned, and another home was built. This too is now gone.

Before the town of Ketchikan was built, members of the Kadjuk and related houses owned the land at the mouth of Ketchikan Creek. Here they had a summer camp and several

57

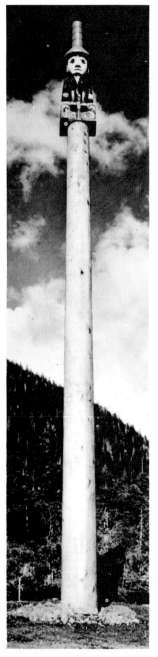

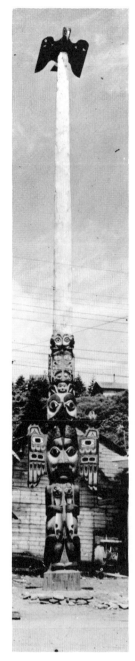

Fig. 27.
Copy of Seward Pole

Fig. 28.
Chief Johnson's Pole

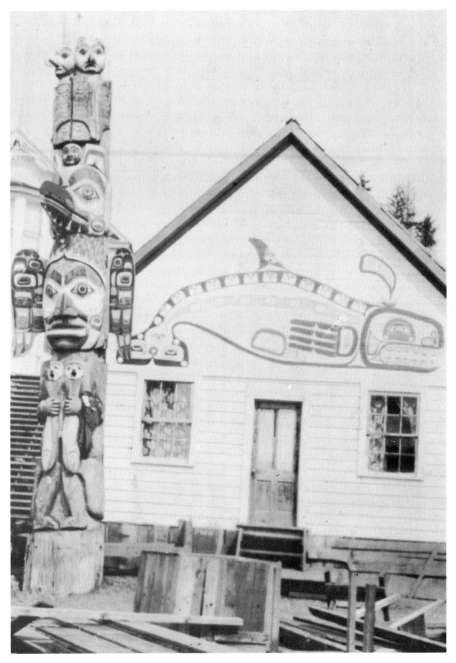

Fig. 29. *Whale Painting on Old House*

large smokehouses where salmon, caught at the mouth of the creek, were dried for the winter.

On top of the pole is the fabled bird called Kadjuk. It is as large as the blue hawk, which it resembles, and lives high in the mountains, never descending to lower elevations. Some say that it is brown in color with black-tipped wings and tail, while others maintain that it is white. It has not been seen for many years. This bird is a special crest of the head of Kadjuk House and may not be used by others without his express permission. The undecorated space separating Kadjuk from the other figures symbolizes the lofty habitat of the bird and the high regard in which the crest is held.

The two bird figures side by side below Kadjuk are Gitsanuk and Gitsaqeq, slaves of Raven, who is shown just below them. The breast of Raven forms the headdress of his wife below him, and his wings extend on either side of her head. The woman wears in her lower lip one of the immense plugs that marked a woman of rank among the ancient Tlingit. In her hands she holds two salmon, the first in the world, which she produced. The two faces above the tails of the salmon represent wealth in the form of the two slaves carved higher up on the pole, and also the wealth of fish which people now have. The woman is called Daughter of Fog Over Salmon, or Fog Woman. The Indians identify her with the midsummer runs of salmon, when low-lying fogs about the mouths of streams coincide with inshore runs of fish. She miraculously produced all the varieties of salmon and put them in the creeks.

All of the figures on the pole, with the exception of Kadjuk, symbolize a single story in the adventures of Raven. An older and shorter pole with the same carvings stood in the old village on Cat Island.

Long ago Raven and his two slaves, Gitsanuk and Gitsaqeq, built a camp at the mouth of a creek and went fishing for their winter food.

Raven caught only bullheads, so they decided to return to camp. As they paddled across the bay a heavy fog came up and they could not see their way to shore. They were lost. Suddenly a woman was sitting in the center of their canoe, and neither Raven nor the slaves knew how she came to be there. She asked for Raven's spruce-root hat, which she held on her left side. All the fog went into it, the sun shone, and they were able to get to camp.

Soon afterward Raven planned another fishing trip. He left his wife, Fog Woman, in camp with Gitsanuk and took Gitsaqeq with him. While they were away, Fog Woman and Gitsanuk became hungry and she commanded the slave to fill a water basket from the spring and set it down in front of her. She dipped her finger into the water. Then she commanded him to pour the water out toward the sea. The slave did as she directed and found a large sockeye salmon splashing about where he had poured out the water. She told him to club the fish and cook it before Raven returned. After the big meal she commanded the slave to clean the meat from between his teeth so that Raven would not know they had had anything to eat. She also instructed him not to tell Raven, under any circumstances, what had happened.

When Raven landed, Gitsanuk ran down to meet him. He was filled with happiness. Raven was very smart and he always found out the secrets of the people. He saw a bit of meat between the slave's teeth and asked him, "What is between your teeth?" The slave replied, "Oh, nothing. That is only the flesh of bullheads." Raven was very insistent and finally became so angry that Gitsanuk told him about the sockeye.

Raven sent for his wife and asked her how she got the salmon. She loved her husband, so she told him the secret. She told him to bring his spruce-root hat full of water just as she had commanded the slave. Raven was so hungry that he hurried out and got water and placed it in front of her. She dipped four fingers into the water and commanded him to pour it out. He did and there were four sockeyes flopping on the ground. They cooked the fish and had a fine meal.

When they finished eating Raven asked Fog Woman if she could produce more fish, for these were the very first salmon. She told him to build a smokehouse first. When it was finished, she directed Raven to bring her a basket of water once more. This time she washed her head in the water. She then ordered him to pour the water back into the spring from which he had taken it. Instantly the spring was filled with sockeyes. They cleaned the fish and put them in the smokehouse to dry. There were

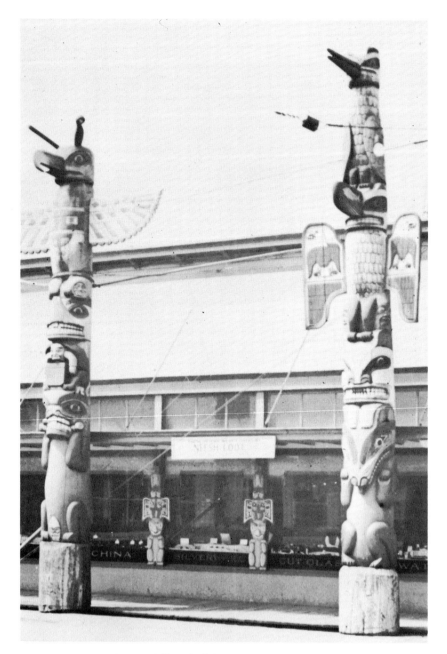

Fig. 30. Thunderbird and Crane Carvings

so many that Raven built a storehouse. They filled the storehouse with salmon and there were enough to fill the smokehouse again.

Raven was so full of joy that he began to talk carelessly to his wife, disregarding the fact that she had brought the fish. They quarreled, and finally Raven struck her. She told him that she would leave and go back to her father's place. Still he talked badly to her. Fog Woman began to brush her hair. A peculiar sound like the rush of wind came from the smokehouse. She left the house and walked slowly toward the water and the sound became louder. When Raven saw that she was really leaving he ran after her and tried to catch hold of her, but his hands slipped through her as through fog or water.

As Fog Woman slowly walked toward the sea all the salmon followed her. Even the fish on the racks and the dried ones wrapped in bundles rolled after her. Raven commanded his slaves to save some of the fish, but they did not have the strength to do so. Fog Woman disappeared from sight, taking all the salmon with her. Raven was so tired trying to save some of the fish that he sat down by the fire in his house. He said to his slaves, "What happened to us is all right. We can use the fish we have in the storehouse for winter." He did not know that they too were gone and that he had no food left, except a few bullheads.

Because Fog Woman produced salmon in the basket of fresh spring water, they return each year. At the head of every stream dwells Creek Woman, daughter of Fog Woman. It is said that Creek Woman brings salmon to the streams now.

THUNDERBIRD AND CRANE POLES
(FIGURE 30)

THESE TWO CARVINGS were made to order for their present location and do not represent any particular native legends. They were carved by Sidney Campbell, a Tsimshian Indian from New Metlakatla. He was born at Port Simpson, British Columbia, about 1846 and died in 1935. He was one of the famous Tsimshian carvers, especially adept in the art of making complicated masks and stage properties with movable parts.

The figures on the right-hand pole are, from top to bottom, the crane, the thunderbird, the sea lion (represented with a human face and flippers under the chin), and the wolf.

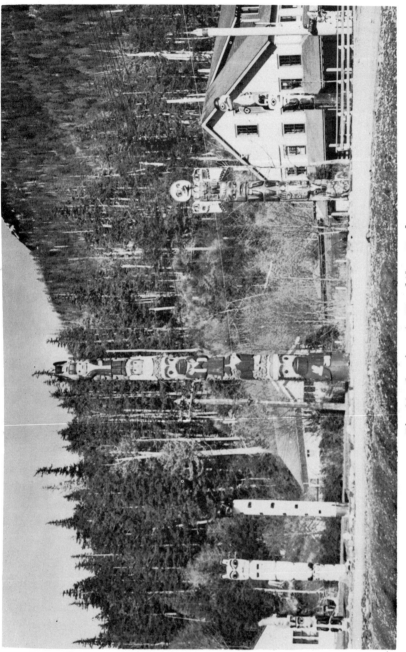

Fig. 31. Carvings in Ketchikan Park

The thunderbird is also carved on the top of the left-hand pole. The antennae-like ears and horizontal wings of the thunderbird are much more characteristic of the art of Vancouver Island tribes than of Tsimshian or Tlingit carving. Artists of the latter tribes carved the same type of ears for animals, birds, and supernatural beings and usually carved birds with drooping or half-closed wings. Mr. Campbell recognized the southern origin of the thunderbird figure, but carved according to directions given him. At the base of the pole is a beaver with a stick in his teeth. His tail is represented as a human face. Between the thunderbird and the beaver are two human figures, the smaller one holding a carved chest, such as was used in ancient times to store valuable possessions.

POLES IN CITY PARK
(FIGURE 31)

THE POLES in this photograph, with the exception of the tall one in the center, were brought from Tongass Village by the American Legion Post of Ketchikan. They are all commemorative or memorial carvings and once stood in front of plank community houses in the old village.

The pole on the left is surmounted by a sea lion, crest of the people of Sea Lion House, who also own the second pole, popularly known as the Wayward Husband. He is Dancer, a famous gambler from Klawak, who is credited with the discovery and settlement of Tongass. Dancer's wife threatened to leave him if he did not stop gambling. For a while he was a model husband. Then he got into a game and lost everything he owned. He took his nephews and left the village. After many adventures they came to Tongass Island, where they built a house. Later others from Klawak joined them, and Tongass became their new home.[5]

[5] John R. Swanton, *Tlingit Myths and Texts.* Bulletin 39, Bureau of American Ethnology, 1909. Page 233 et seq., for detailed account.

The third memorial illustrates the story of Kats and his bear wife (see page 29). The carving shows her as she ascended the mountain, mourning the death of Kats. Her tracks on the pole symbolize the trail she followed.

To the right of the tall center pole is the Sun and Raven memorial, a copy of which is in Saxman Park (see page 15). Next to it is a carving symbolizing Thunder, belonging to Thunder House people. According to legend, four brothers belonging to the clan were changed into Thunderers. When they move their wings, thunder is heard; and lightning flashes when they wink their eyes. They live in the sky and are very powerful beings.

A photograph taken by Albert P. Niblack in 1885 shows this pole in good condition. A large carving of a whale with upright dorsal fin lies on a wooden platform on either side of the base of the pole. The picture is captioned, "In front of the feast house of Chief Kootenah at Tongass Village."[6]

Next to the Thunderer is a plain shaft with a carving of a ship on the front. This also belongs to the people of Sea Lion House who own the two poles described above. A figure of the sea lion, their main crest, originally surmounted the shaft. It is a memorial for the woman whose figure appears above the ship. Her Tlingit name was Calm Woman, or Woman of the Calm. Though the carvings are popularly believed to represent Captain Vancouver, who explored in the area in 1793-94, and his ship, this is not true. Calm Woman was married to a Captain Swanson, and the carving of the ship on the pole represents the vessel he commanded. The figure of Calm Woman has been erroneously identified as that of the ship's captain. The stripes on the sleeves might lead to that interpretation. However, the plain black blouse with round, collarless neck was quite the

[6] Albert P. Niblack, *The Coast Indians of Southern Alaska and Northern British Columbia.* Report of the U.S. National Museum, 1888. Plate LV, figure 294.

fashion in the late nineteenth century, and the style of hair —parted in the middle and drawn smoothly over the ears—was also fashionable. This is a portrait of Calm Woman as she appeared shortly before her death.

The tall pole in the center (Fig. 31) is the only Haida carving in Ketchikan. It was brought from Old Kasaan on Prince of Wales Island, together with four carved posts from the house in front of which it stood. They belonged to Chief Skowl, one of the wealthy and influential clan heads.

This carved column is unusual in that only one conventionalized figure from native legend appears on it—the eagle crest at the top. The other figures are symbolic of Skowl's defiance of the efforts of the Russians to introduce their religion in Kasaan.

Part of the distinctive style arose from the artist's problem of successfully representing the Græco-Russian faith and its purveyors. That the three men on the pole are non-Indian is clear. When native artists began to depict the white invaders, they selected beards, curly hair, white faces, and clothing as identifying symbols. On full-length figures, shoes are always shown, while footgear never appears in representations of purely native characters. Occasionally designs such as the scrolls used to fill in between the figures on the Skowl column are also used further to emphasize the foreign subject illustrated. The postures of the figures on this pole, especially the crossed hands, are not found on any carvings of legendary characters.

Skowl sponsored the carving of this pole, though the eagle crest belongs to his wife and children. On a true Haida totem pole, carvings symbolic of the legends of the wife's clan occupy approximately half of the pole; those of the husband's clan occupy the other half. One of Skowl's daughters married Charles V. Baronovich, an Austrian who established a trading post near Old Kasaan in 1860. After his death she helped her father finance the carving and dedication of the column, and

her crest appears at the top. In a sense it is a memorial to her husband. The carving was done by John Wallace's father, one of the noted Haida artists of the late nineteenth century. The dedicatory potlatch was given about two years before Skowl's death, which occurred in the winter of 1882-83.

Though interpretations of the identity of the figures on this pole are not consistent, all agree that the carvings refer to the Russians and their attempts to Christianize Skowl and his tribesmen. Albert P. Niblack, who visited Kasaan in 1885, reproduced a photograph of the pole and described it as follows:

It was erected in front of the feast house of the famous Kaigani Chief Skowl at Kasa-an. This is in the rear of the living house, on the back street, so to speak. In front of the latter is his totemic column, a tall, slender, finely carved one, surmounted by his totem, the eagle, resting on seven disks. The feast house column is surmounted by Skowl's crest, the eagle. Just below it is a carved figure of a man with right hand uplifted and index finger pointing to the sky. It signifies that in the heavens God dwells—the God of the white man. Below this is the representation of an angel as conceived by the Indians from the description of the whites, and then comes a large figure intended to picture a Russian missionary with hands piously folded across the breast. This group of the figure with uplifted hand, the angel, and the missionary, commemorates the failure of the Russian priests to convert Skowl's people to their faith, and was erected in ridicule and derision of the religion of the white man. Below this group is a magnificent carving of a spread eagle, and at the bottom of the column a figure intended to represent one of the early traders on the coast. Skowl was always an enemy to the missionary and resisted their encroachments to the last, being remarkable for his wealth, obesity, and intemperate habits. He weighed at the time of his death, in the winter of 1882-83, considerably over three hundred pounds. As a young man, his physical prowess, wealth, and family influence made his tyrannical rule at Kasa-an one long to be remembered, as he did much to keep his people to the old faith and to preserve amongst them the manners and customs of his forefathers.[7]

A sketch of Chief Skowl lying in state in his house is also reproduced from a photograph taken by Niblack. Carved chests,

[7] Niblack, *op. cit.,* page 327, Plate LV, figure 293.

masks, copper plaques, and other heirlooms surround his blan-
ket-draped coffin. The chests were filled with ceremonial dance
paraphernalia and other wealth.

The account which T. T. Waterman obtained in 1922 is
widely at variance with Niblack's:

> It is not properly speaking an example of totemic art at all. The owner's
> wife was an Eagle woman, so the Eagle appears at the top of the pole. The
> owner himself many years ago, prior to the American occupation of
> Alaska, became converted to Christianity. The three figures on the body of
> the pole were copied, along with the scroll designs, from a Bible in the
> Russian church at Sitka. The bottom one represents, it is said, St. Paul.
> The pole, while it is not a totemic monument as far as the designs on it
> are concerned, illustrates how an individual's inner experiences give rise
> to crests. This man gave a great potlatch when he raised the pole, and thus
> endowed himself with title to these carvings, and made them his own. He
> was the first of his group to become a Christian.[8]

In 1938 Linn Forrest recorded an explanation of the carving
which differs from the two previous accounts:

> This pole was carved to commemorate the event when Chief Skowl and
> his family were baptized into the Græco-Russian church at Sitka.
>
> The top figure is the eagle, crest of the great Chief Skowl, next is a
> Russian saint. The third figure is the head of the archangel, Saint Michael,
> and the fourth is a Russian bishop. The last two figures are a white man
> surmounted by an eagle.
>
> This pole clearly shows the trend in totemic carving from the more
> primitive native style to the conventional style as copied from designs
> taken from the Russian Bible.

Members of Skowl's clan were consulted by the editor in an
effort to reconcile the above accounts. They agreed that the pole
was carved to show Skowl's defiance of missionaries and the
Christian religion, that not only had he not been converted but
he had earnestly tried to preserve all of the old customs as far
as possible. The eagle at the top of the pole was interpreted as
the crest of his wife and daughter, while the spread eagle near

[8] Waterman, *op. cit.*, page 125, figure 120.

the base was intended to symbolize the Russian eagle and hence was carved quite differently from the crest figure, which was the only crest represented.

The consensus was that the man at the base of the pole represented Skowl's son-in-law, who was well known for his trading and commercial ventures. Identification of the other carvings was uncertain, though it was agreed that they were either Russian religious men or saints. The small face with wings on either side was identified as an angel. Niblack's account, therefore, seems to be the more nearly accurate interpretation.

According to one native interpretation, the pole calls attention to the fact that the Indians received none of the purchase money when Russia sold Alaska, though the land rightfully belonged to them. The Haida eagle "holds down" the Russians until they pay the debt.

MUD BIGHT VILLAGE

WHEN THE Forest Service started
the totem pole restoration program in 1938, one of the projects
planned was the building of a model town at Mud Bight, seven-
teen miles north of Ketchikan. The site, in Tongass National
Forest, was selected because it had been a Tlingit campsite for
many generations. Here a wide gravel bar with a fringe of
trees formed a protected cove suitable for the landing of canoes
—a special advantage in this region where the coastline is gen-
erally rocky and gravel beaches few and far between. A creek
flowing into it furnished fresh water and attracted salmon.
Back of the bar, the woods (now traversed by a highway) pro-
vided berries in season and deer for the campers. It was a
pleasant spot for a summer camp, open to the sun and sheltered
from the wind. It can now be reached by automobile or bus from
Ketchikan, and it is visible from northbound steamers.

The plans for a village of dwellings, smokehouses, grave
houses, and totem and mortuary poles were drawn by Linn For-
rest. Poles and other carvings from all the Haida and Tlingit
groups now represented in Kasaan, Hydaburg, Klawak, Sax-
man, and Ketchikan were to be included. Copies of carvings
from deserted towns as well as new carvings designed especially
for the site were planned. The outbreak of war prevented com-
pletion of the project.

The dwelling, the entrance pole, and the column on the point
in front of the house were constructed by Civilian Conservation
Corps workers from the Saxman workshop (Figs. 32, 34).

71

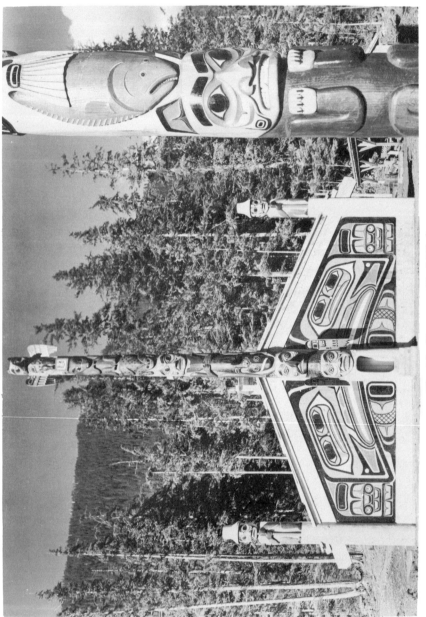

Fig. 32. House at Mud Bight

Charles Brown, head carver, designed the carvings and house-front painting and furnished the stories explaining them. The house is modeled after those built in the early nineteenth century. The inside is one large room with a central square fireplace, around which is a planked platform. This space would have served as living quarters for several families, each allotted to its own space but sharing the common fire. The smoke hole is protected by the movable frame and cover for keeping out rain and wind. A low, oval entrance was typical of ancient homes, but the carved column against the front of the house is a more recent innovation. A painted design on the house front was never common; only a few homes were so decorated. This painting is of a stylized raven with each eye elaborated into a face. On each of the front corner posts sits a man wearing a spruce-root hat. With a crest design painted on his face and a cane in his hands, he is ready for a dance or a potlatch.

Most of the Tlingit now living at Ketchikan and Saxman belong to the Cape Fox and Tongass tribes, and all of the legends illustrated belong to lineages of these two tribes, though many of them are shared by other Tlingit. Several of these legends are also symbolized on the poles in Saxman and Ketchikan and have already been related. However, since some of the versions differ in many details, they are included here.

The carved posts supporting the beams inside the house (Fig. 33) symbolize the exploits of a man of the Raven phratry who showed his strength by tearing a sea lion in two. The weasel-skin hat which he wears belonged to him and his clansmen. The following is an account of his adventures.

Many years ago the people hunted sea lions. In those days when spears and bows and arrows were used, the hunters were compelled to approach close to the animals, and sometimes the men would surround a herd of sea lions. On one hunting trip a man was caught by the flapping tail of the largest of all sea lions and was killed. His companions took his body back to the village and vowed that his nephews would come out some day and

73

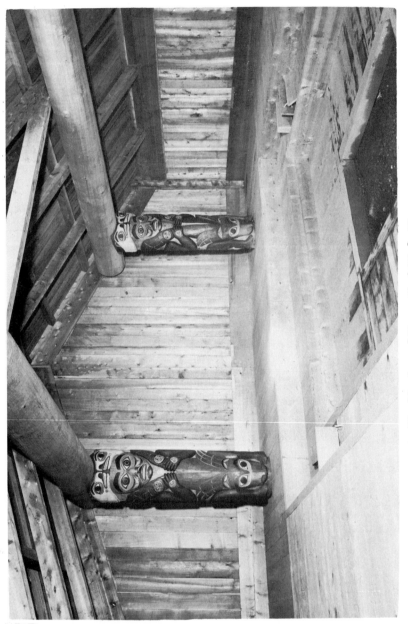

Fig. 33. Carved Posts, Mud Bight House

kill the bull sea lion with their bare hands. After all the ceremonies were over, everyone in the village went into training. Day after day, while the north winds blew in midwinter, they sat in ice-cold water each morning before dawn.

There were two brothers who were the nephews of the dead man and who were outstanding. They were very strong, and people looked up to them. They planned a test for the men of the village. At one end of the village was an old dry tree with a limb at the base. As each man left the salt water he went to this tree and tried to pull out the limb. At the other end of the village was a small live spruce tree about eight feet tall. If a man thought he was strong enough he would try to twist it to the roots. Even after many weeks of training no one succeeded.

There was a very meek man in the village who was always laughed at and kicked about. He appeared lazy. Although he did as much as any of the men he concealed his training. As soon as he heard the men come in from work in the evening, he would go out and sit in the salt water until he was unable to stand and had to crawl to the house. Then he would lie in the warm ashes. He was so dirty that they called him Blackskin. When the others went out in the early morning they kicked him and made insulting remarks about his laziness. Blackskin said nothing but lay with his head covered. Only his uncle's wife, the widow, knew what he was doing. She had great confidence in him and encouraged him in every way. Night after night for months he trained, while the other men trained during the day.

One night while he was in the water, a small man appeared on the beach and called to him. The small man said, "I am Strength; I am the Strength of the North Wind. Come and try to throw me." So they scuffled on the beach, but the little man threw Blackskin. Strength said, "You are not yet ready to pull out the village nose," meaning the limb from the dry tree, "nor are you ready to twist the village tree. I will come again to test your strength."

After many more nights the small man again appeared on the beach and asked Blackskin to come and wrestle with him. This time he threw Strength. Then Strength said, "Now go and twist the village tree." He went to the tree and twisted it right down to the roots. Strength said, "Straighten the tree," and he did. Then he directed, "Now go to the village nose and pull it out." A slight twist and Blackskin pulled the limb from its socket. He urinated in the socket and pushed the limb back as he was told. Strength said, "Now you are ready to fight, for you are even stronger than North Wind."

75

The next morning the other men went out to train as usual. The two brothers who were supposed to be stronger than anyone else were always given the first chance at the village tree and the village nose, and they were the two that made life miserable for Blackskin. That was the reason he put the limb back and untwisted the tree as he did. One of the brothers walked up to the tree and twisted it down to the roots. The other brother pulled out the limb. Immediately all training stopped and they made ready to fight the sea lions with their bare hands. Only the strongest were picked to go along.

The hunters were ready to leave for Sea Lion Rock. Blackskin also made ready to go. He asked the widow, "Where is my uncle's weasel-skin hat? Give it to me, and I will also go to Sea Lion Rock." He stood on the beach by the stern of the canoe, begging to be taken, but the men refused. He took hold of the canoe by the stern piece and held it, in spite of the efforts of the men to paddle away. The two brothers pushed against his chest with their paddles while he begged to be taken. They still refused. He was really angry then and pulled the canoe half out of water onto the beach saying, "I only want to go along to bail out the canoe. I will not be in anybody's way." Even then the men did not realize he was so strong that he had pulled the canoe up with all of them in it. They had to get out to push it back into the water. They let him go with them.

Sea Lion Rock is off the west coast, out in the Pacific Ocean and there were very large swells rolling in. The waves washed up on the rocks twenty to thirty feet high, and landing was difficult. The oldest brother stood on the bow of the canoe and finally made the jump. He almost missed the rock. The sea lions seemed to know the men were there to fight, and they were ready to defend the rock, which was their home. There was no doubting that this brother was strong. He walked through the herd of small and medium-sized animals, striking them right and left and cracking their heads together. Finally he came to the bull sea lion. He caught it by the tail and started to tear it in half, but the bull sea lion lifted his flipper and smashed the man against the rocks. Then the younger brother jumped onto the rock and tried to kill the bull sea lion, but the same thing happened to him.

By this time Blackskin voiced what he thought, saying, "It was I who twisted the village tree, and it was I who pulled out the village nose, and I too am the nephew of the man who was killed on this rock." Putting on his uncle's weasel-skin hat, he said, "I too have been sitting in salt water in order to avenge my uncle." He then started for the bow of the canoe and the seats broke at his shins as he walked. He watched the waves and

jumped, landing safely on the rock. He walked up through the sea lions, picked up small ones by the tails and dashed their heads against the rocks. He killed the medium-sized ones with one blow. He took the biggest sea lion by the tail and ripped it in half. Thus Blackskin avenged the death of his uncle.

When the men returned to the village and told of Blackskin's feat, the people looked upon him as a great man and he became head of the town. When he wanted wood he did not chop a tree down, he took hold of it and broke it off. Then he broke the tree against a rock and supplied the whole village with wood. He supplied the people with everything they needed.

Later Blackskin began to play tricks on those who professed to be very strong. He tested the strength of two brothers by carrying a very large boulder to the door of their house. He amused himself by watching them struggle with it, and they were annoyed. They prayed that they might avenge themselves for all the embarrassment Blackskin caused them.

In the fall the two brothers left the village for camp and told no one of their plans. As soon as it was cold enough they began sitting in salt water, and when it was frozen they chopped holes in the ice. They took turns sitting in the icy water. When one was so cold he was unable to walk, the other would take him to the house to get warm. When they were toughened to this they beat each other with hemlock boughs. After a while they were so tough that they did not bleed.

Toward spring they returned to the village. One morning they found their door sealed with a very large rock which Blackskin had put there. The older brother said, "Throw the pebble down on the beach," and the other one did so with no effort.

By this time they were two against one, and together the brothers were stronger than Blackskin. They put boulders in front of Blackskin's door and he struggled to move them. This went on for some time until it came to a showdown and a challenge to battle to death was made. They agreed to stand face to face and poke each other, using the pointing finger to strike at the body. They took turns. First Blackskin would strike, and then one of the brothers. The brothers killed him, and so ends the story of Blackskin, the strong man.

The pole against the front of the house (Fig. 32) is called Wandering Raven, from the legendary Raven carved as the top figure. At his feet is the box containing daylight. At the lower end of the pole is Raven at the Head of Nass, the powerful chief who owned the sun, moon, and stars and who is identified by the

large turned-back beak. He was Raven's grandfather. Below him is Raven's mother with a large labret in her lower lip—the mark of a high-class woman. These three figures illustrate the feat of Raven, who brought daylight to a dark world.

Very long ago Raven was wandering down from the north. He met many people on the way. He was often hungry, but he was full of tricks and usually outsmarted fish or game so that he got food. Some creatures, like the bullhead and devilfish, he could not fool. These he cursed and turned into rocks, which may still be seen. Raven encountered whales, bears, king salmon, birds, and humans on this journey. He was seeking something to cause it to be daylight, for it was then dark all over the world. Everywhere he went he met humans and animals who hoped and wished for daylight. Finally he came to Nass River. At the head of the Nass lived a great chief, called Raven at the Head of Nass, who owned the sun, moon, and stars. On the way to his house Raven was hungry and begged for fish from some people who were fishing in the river. They would not give him any and ridiculed him when he promised to exchange daylight for food. They told him to work for his own food and made scornful remarks about his laziness and reputation as a trickster.

Raven went on up the river asking all the people he met for food. Each time he was refused. By this time Raven was really angry with human beings.

After many days of traveling he finally came to the place where the great chief lived. Then he planned how he could get into the house. The chief had learned of his coming and had instructed his many slaves to keep Raven out. The chief had a daughter who was closely guarded. Everything that she ate or drank was inspected and tested before it was given to her. Raven decided to try to get into her drinking water. He turned himself into a particle of dirt and placed himself in her drinking basket, but being dirt he sank to the bottom and was thrown out. Then he turned himself into a hemlock needle of very light color and was not noticed. When the chief's daughter drank the water she swallowed the hemlock needle.

Sometime later it was apparent that the young woman was pregnant. There was great confusion about the condition of the woman, for she had been constantly attended by slaves. Great medicine men were called, but no one could undo the trick of Raven. In due time he was born as a human child. His grandparents became very fond of the baby. One day his grandmother picked up baby Raven, and his ruse was almost exposed.

She said, "There is something very queer about this child. Under its skin it feels almost like feathers."

Raven grew very fast and soon began to cry and beg for the moon that hung on the wall. Though his grandfather was very fond of him he did not want to give him the priceless treasure to play with. Finally, when Raven cried so hard they were afraid he would make himself ill, the moon was given to him. Immediately baby Raven stopped crying and rolled the moon about the floor joyfully. After a day or so he gave the moon a toss and it went up through the smoke hole in the roof and into the sky. Raven pretended to cry because he had lost his plaything.

Raven then began to beg for a box in his grandfather's house. He knew that it contained the light of the world. Day after day, night after night he cried, until the box of daylight, priceless above all things his grandfather possessed, was taken down and given to him. He stopped crying and played about the house with the box, waiting for a chance to make off with it, but this time the slaves were watching him very closely. One day he saw a chance and flew for the smoke hole. A very large fire was burning in the fireplace and Raven counted on the upward draft to carry him through to freedom. The chief saw him and commanded him to stop. So great was the chief's power that Raven was stopped at the smoke hole. He called all the powers that he had ever had into his wings and escaped.

Then Raven started down the river with the daylight box. He came to the camp where the people had refused him food and asked them for something to eat. When they again mocked him he said, "Will someone give me food, or shall I turn night into day?" They told him to go and get his own food. Raven threatened, "If you do not give me food I will open this box. You will all be frightened to death. You will turn into the animal whose skin you are now wearing." They only laughed at him. Raven lifted the cover of the daylight box; with a thundering flash the world was light. As he had foretold, the people who were wearing skin garments turned into animals and ran away. Some became sea animals, some land animals, and others birds. Those who wore no clothing remained human.

The above story is symbolized on a number of carved poles, including the totem pole in Pioneer Square, Seattle, which came from Tongass Village.[9] On the latter column Raven is at the top,

9 Viola E. Garfield, *The Seattle Totem Pole*. University of Washington Extension Series, Number 11, July 1940.

holding the moon in his beak. His grandfather is at the base of the pole.

On the Mud Bight entrance pole Mink is below Raven and symbolizes one of the spirit helpers of a famous shaman, or medicine man, who lived long ago on Village Island. This shaman cured the sick and foresaw many things weeks or even years before they happened. He was a great blessing to his people, and his descendants carved his most reliable spirit power in memory of him. Mink is also carved on the Seattle totem pole.

The frog below Mink on the entrance pole recalls an experience of a woman who lived in ancient times in a village somewhere between Prince Rupert and Port Simpson, British Columbia.

A young woman saw a frog in her path and made a slighting remark about frogs. This was a serious offense which the Tlingit firmly believed would be punished. Soon afterward she met a handsome young man who asked her to marry him. [He was really a frog but he looked like a human being to her.] She agreed to meet him at a certain lake in the woods. He told her he would take her to his home where his father was a chief. At the edge of the lake he instructed her to step on a patch of water lilies. She was afraid until he stepped on them. They followed a path and were soon in a large village. He took her to his father's house, though she did not know it was the frogs' home beneath the lake.

Knowing that the young woman had offended the frogs, her relatives decided to give a feast to them in the hope that they would return her. An invitation was delivered to the lake and the feast prepared. Toward evening they saw the young woman with two frogs, a large male and a small one—her husband and child. They were sitting on a marshy spot in the middle of the lake but soon disappeared. Then her relatives drained the lake and recovered the young woman. She related her experiences but did not live long afterward.

It is said that those who live extremely pure lives may sometimes see her rise from the center of the lake. One must fast many days and follow strict taboos in order to see her, but great luck and riches will come to him who succeeds. She is most apt to be seen when the sun is shining on the water. Then her hair gleams with a bright luster.

The young woman and her frog husband and child are carved on the pole on the point in front of the house (see Fig. 34), and on the Seattle totem pole.

Below the frog is the standing figure of a man who holds the tail of a blackfish or killer whale. He is Natsihlane, who carved the first blackfish and brought them to life.

This man was from the north and was married to a woman from the village on Duke Island. He was living with her relatives, which was unusual, since most women went to their husband's villages to live when they married.

The woman had many brothers who were jealous of their brother-in-law. The men of the village often went after sea lions to a place known today as West Devil Rock, a great distance from land. Each time they came to the rock Natsihlane was the first one ashore, and he started killing sea lions without waiting for the others. When they got ashore, all the animals had either been killed or had escaped into the water. He thought that he was doing them a great favor by killing so many, for he was trying to earn the respect of his wife's people by doing more than his share of work. Instead, he was causing hard feelings in the hearts of his brothers-in-law. They talked among themselves as to what they should do with him and finally decided to take him hunting and leave him on the rock.

The men planned a sea-lion hunt. They got everything ready, and everyone was happy as they started off before daybreak. After many hours of paddling they reached the rock, and as before Natsihlane was the first one ashore. The men watched their chance and, when he crossed to the other side, they pushed off and paddled away. They planned to tell his wife that he had speared a sea lion from the canoe and had been pulled overboard and drowned. As they left the shore the youngest brother-in-law begged them not to leave him. He cried, "Don't leave him, don't leave him, he will die. Turn back! Turn back!" They paid no attention to him, but the condemned man heard him calling until they were far from the rock.

Natsihlane was left without food or water and with only his spear to get food for himself. He tried to spear a sea lion, but the point broke. He sat down on the lee side of the rock feeling very forlorn and began to sing songs of his forefathers, songs of death and mourning. Finally he lay down, pulled his blanket over his head, and fell into a worried sleep.

Early the next morning, just as the sun was coming up, he heard his name called. He heard it so clearly that he sat up and looked around. There was nothing to be seen but a few birds overhead and the waves pounding

on the rock. He thought to himself, "I must have been dreaming," so he lay down, covered his head with his blanket, and went to sleep again.

Again Natsihlane heard his name and again he looked about sharply. He saw only a medium-sized sea lion and a seagull. He lay down and covered his head with his blanket, taking care that he could look out. He pretended to be asleep. Again someone spoke his name and he saw a sea lion step out of the water, though he thought it was a man. He called out, "I have seen you, why do you call me?" The sea lion answered, "I have come for you. The chief of the sea lions wishes to speak to you. Follow me."

The sea lion went to the east side of the rock where there was a low cliff. The rock opened up, and they entered a large house. In the rear lay a very sick sea lion, though it and everyone else looked human to Natsihlane. A medicine man was working over the patient, but he could not see what was causing the illness. Natsihlane saw his broken spear point sticking in the man's side and immediately knew that this was the sea lion he had tried to kill. He thought, "I can save this man," and the sea lion chief knew his thoughts. He said, "We have seen; come and save my son."

Instead of pulling the point out Natsihlane merely touched it, thinking, "If only these people would help me, I could get to the mainland and home." The sea lion chief knew his thoughts and replied, "Your wishes shall be granted." Natsihlane then removed the spear point, and the patient was well.

The chief said, "Tomorrow, before the raven calls, you will be on land." They prepared a dried sea-lion stomach, put the man and some food inside, and instructed him to keep the mainland in mind and not to think of the rock or the people he was leaving. The sea lions then passed the craft over the water four times, pointed it toward shore, and let it go. Natsihlane had drifted for some time when he forgot instructions and thought of the people who had saved his life. Immediately he was pounding on the rock, though he did not know where he was until the sea lions came out and rescued him. They again passed the skin over the water four times and started it toward shore. This time Natsihlane sang a song of West Wind and kept his thoughts on the shore.

After many hours of drifting he knew that he was on shore, but the waves were washing him back and forth on the beach. He waited until the tide went out and the craft was stranded before he emerged. West Wind had carried him ashore in a bay only a few miles from his own village. He stayed there four days and then went to the village late at night. He went to the corner of the house where his wife slept and knocked

lightly on the wall. He whispered to her that he was home and asked her to give him his tools. He went back to the bay where he had landed and built himself a hut of driftwood.

Then he began carving. He was planning a way to kill his brothers-in-law. He carved a blackfish. Then he built a chain of four pools on the beach, the last one leading into the sea. He put the carving in the upper pool. It made one jump and sank to the bottom. He tried all kinds of wood. Some of the creatures swam to the second pool and some into the third, but none of them came to life. Finally he carved one of yellow cedar and placed it in the first pool. It swam around, then jumped into the second pool, then on into the third and fourth pools and into the sea.

Natsihlane then called the blackfish to him and instructed it to find his brothers-in-law, destroy their canoe and drown them, but to save the youngest brother-in-law who had pleaded for his life. Several nights later he had a dream in which the blackfish appeared as a human being and told him the canoe had been destroyed and all his brothers-in-law except the youngest were dead. He had been carried to shore on the broken half of the canoe. Then Natsihlane knew that his instructions had been carried out. He called the blackfish to him and instructed it never again to harm human beings, but always to assist them.

The power to make blackfish was given Natsihlane by the sea lion chief, and he was only carrying out the wishes of the latter. After taking revenge on his enemies Natsihlane became a wandering thing of the woods. It was never told what became of him.

POLE ON THE POINT
(FIGURE 34)

ON TOP OF THIS very tall pole is a shaman dressed in ceremonial garb. He wears a headdress of bear claws and a painted and fringed leather apron. In his hands is a carved symbol of one of his spirit powers. Below him are a halibut and two land otters, also spirit aides of the shaman, who assisted him in the performance of magical acts, such as the curing of disease and the foretelling of events.

Below is the eagle with outspread wings, and a man holding a salmon by the tail. These figures recall the story of the chief's nephew who fed eagles.

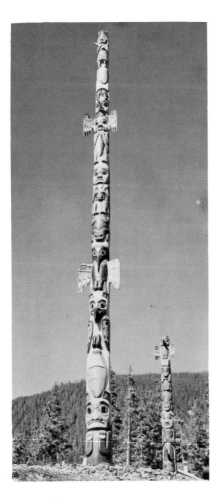

Fig. 34. Pole Designed for
Mud Bight

Fig. 35. Master Carpenter

At a village near Port Simpson, British Columbia, was a young man who spent the summer catching salmon, which he took to a long spit for the eagles. When the eagles shed their feathers, he picked them up and used them to feather arrows. The young man's relatives urged him to help catch salmon to dry for winter, but he paid no attention to them. People began to make remarks about his laziness, which humiliated his uncle, who was a very wealthy chief. Fall came, and still the nephew did nothing but feed eagles.

Late in the winter the food supply in the village was very low. There were storms so that the men could not go out to catch fish, and finally they were faced with starvation. The chief decided that they would move earlier than usual to the Nass River eulachon fishing grounds in the hope that they could find food.

Secretly he planned the time of departure, for he had decided to leave his lazy nephew behind. When they were ready to leave, he ordered that all fires should be put out and every bit of food taken. The boy's grandmother, who felt sorry for him, left a live coal in a clam shell and a little food hidden in a box.

The boy was very lonely, but he went to the spit each day to feed eagles. One morning he found a fish there. He took it up and cooked it. The next morning the same thing happened. Every day he brought up something that the eagles had left—a salmon, halibut, seal, and finally a whale. He cut up the meat and dried it over slow fires and stored it in his own house until it was full. He filled all the empty houses in the village.

Meanwhile the people who had gone to Nass were faring badly, for the eulachon were not running and other food was hard to get. The chief thought of his nephew and decided to send his slaves to find out if he were still alive. The young man welcomed the slaves and fed them well but warned them not to tell his uncle of all the food and not to take any with them. However, the slave woman thought of her starving child at home and hid a piece of seal meat in her blanket.

The slave fed the meat to her child in the middle of the night when she thought no one would discover it. The baby choked, waking the chief's wife, who commanded that the child be brought to her. She put her finger down the baby's throat and pulled out the meat. The slaves then told them of their nephew's good fortune.

The chief decided to return to the village. As the canoes approached, the people saw the water covered with grease and offal from the animals the young man had slaughtered on the beach. The chief's elder daughters were so ravenous that they dipped their hands into the water to skim off

the grease. The young man would not let the people come ashore until they offered all their wealth in return for food. He became very rich and succeeded to his uncle's position as chief of the town. He refused to marry his uncle's elder daughters but asked for the youngest one because she had shown her fine breeding by waiting until she was invited to his house to eat. She had not stooped to skim offal from the water, even though she was starving.

Below the figures illustrating the above story are those of a woman and two frogs. This is the woman with her frog husband and child whose adventures are symbolized by the frog figure on the entrance pole (see page 80).

Below the frog are, in order, Cormorant, Raven, Halibut, and Grizzly Bear, symbolizing the following adventures of Raven.

Raven was wandering around the country with Cormorant as his companion or slave. He met a pair of bears with whom he became very friendly. He suggested to the male bear that they go halibut fishing, taking Cormorant along to paddle, bail, and otherwise serve as his slave.

Raven caught many halibut, but Bear caught nothing. Bear asked Raven what kind of bait he was using. Raven mumbled something Bear did not understand and went on fishing. He again asked Raven what kind of bait he used, and Raven finally told him to cut a piece of meat off of himself if he wanted to catch halibut. Bear protested, but Raven told him his wife would be very angry if he came home without any halibut. Then he began to taunt Bear and call him a coward because he was afraid to cut a piece of meat from himself for bait. Raven wanted to kill Bear anyway because he did not want to share his catch with him. Finally Bear did as Raven directed and bled to death.

Raven then thought how he could prevent Cormorant from telling what had happened. He turned to Cormorant, who was paddling, and said excitedly, "Wait, wait, look this way. What is that in your mouth? Open it and hold still. It is on your tongue! Stick it out." The bewildered Cormorant opened his mouth and stuck out his tongue and Raven took hold of it and pulled it out. "Now talk," jeered Raven, but Cormorant could only mumble.

When Raven and Cormorant reached shore, the female bear asked about her husband. Raven said, "He got off beyond the point and will walk over. He will be here by nightfall." Cormorant tried to tell her what happened. Raven said, "He is trying to tell you that the fishing was very good."

Raven began to cook the halibut, and he thought how he could kill the female bear. He cut out the halibut stomachs and filled them with red hot rocks. When they were ready he called her and said, "People do not chew what I cook. Swallow it whole." She followed directions and soon was in great pain. Raven told Cormorant to bring her water to drink. Steam came from her mouth and she soon died. Raven then ordered Cormorant to go out and sit on the rocks offshore, and that is where cormorants are seen now. Raven ate all the halibut and bear meat himself.

Several poles from Tongass and Cat Island were copied for the Mud Bight village. Among them is a grave marker from Cat Island representing a man wearing a large carved wooden hat, surmounted by a bear's head. The brim is decorated with painted whales. Such a hat was worn at a potlach or other important occasion, during which the stories it symbolizes were told or dramatized. (Fig. 61.)

The bear is said to have been carved originally with closed mouth. A long while ago the chief of the Bear clan was killed, and the murderers refused to make restitution for his death. The Bear clansmen made a new wooden hat, carving the bear with mouth open and teeth bared as though ready to attack an enemy. They then invited the murderer and his relatives to a potlatch and challenged them either to pay for the death of the chief or to prepare for war. The accused still did not pay, so they were attacked. Since then the bear has been carved with teeth showing, as a reminder that the Bear people are proud and will attack their enemies. The whale fin and painted whales on the post represent another crest of the group.

An old Kadjuk pole from Cat Island was also copied. It is very similar to the Kadjuk pole in Ketchikan but lacks the two slaves on the front of the plain shaft. Instead there are two large faces at the base of the pole (see page 60).

One pole for the Mud Bight village was made at the Klawak workshop. The carving was designed, and much of the work done, by Walter Kita, who illustrated three stories belonging to the Raven clan of which he is a member. The pole has not been

brought to Mud Bight and no photographs of it have been made. At the top of the pole is the land-otter man, a human being who drowned and was turned into an otter. Land-otter figures are carved on his head, shoulders, and the front of his body. He holds a rattle in each hand. The figure illustrates one of the well-known folk beliefs of both the Tlingit and the Haida. According to mythology, those who drown are taken by the land otters to their caves or dens, where they gradually turn into the creatures. Since such persons are lonely for their friends and relatives, they try to capture them also; hence land otters and humans turned into land otters are a menace. There are many tales woven around this folk belief, and Walter Kita chose to illustrate the story of the fight with the land otters, of which the following is a condensed version. A longer account is given on page 105.

One day four young men went to Humpy Creek to fish. While they were sitting around the campfire, a frog appeared. One of them threw it into the fire, a very serious offense.

The boys started home, but a storm came up and the canoe capsized. They clung to the overturned craft and called for help. Soon a canoe load of their relatives came and took them ashore. Only when they reached the dens did they realize that these were land otters who had come to their rescue in the guise of relatives.

When the boys did not return home, their relatives set out to look for them but found only the dead campfire and the wrecked canoe. They then called a shaman to look for the boys, and his spirit aides reported what had happened. The shaman advised them to smoke the land otters out of their dens and try to rescue the boys before they turned into animals. The people prepared pitch sticks and smoked the animals out of their dens but were too late to save the boys, who ran off with the land otters.

The shaman then reported that the land otters were going to make war on people for smoking them out of their dens and killing many of their number. Many people were ill and many died; canoes capsized and there were other accidents that took a heavy toll of life. Finally the land-otter chief sent his sons in the form of two white land otters to the village. They were feasted and entertained and they announced that the land otters were coming to make peace with the people. When they came, there was

much dancing and entertainment, though the people were so bewitched by the power of the animals that the whole experience seemed like a dream to them. Since that time people and land otters have not made war on each other.

The second figure on the pole is that of Blackskin, the strong man, in the act of tearing a sea lion in two. This story is also illustrated on the house posts in the Mud Bight dwelling (see page 73).

At the base of the pole is the figure of a woman of the Raven clan who kept a woodworm for a pet. The creature grew into a monster that destroyed the village. The fact that it is carved as a human child symbolizes her devotion to the unusual pet and her tender care in raising it.

Long ago, before the Flood, the people were living at Eagle Winter Village near Klawak. The chief had many slaves and a young daughter who was closely guarded and spent most of her time in her room, for her coming-out party had not yet been given.

One day the slaves were sent for firewood. When one of them split a rotten log with his stone adze, he found a small worm inside. The slaves wrapped it in the paper-like sheets of wood that were its burrow, planning to frighten the chief's daughter with it. When they gave it to her, she was not frightened but took it into her room.

There, unknown to anyone in the house, she fed the worm and talked to it as though it were her own child. The people heard her talking but paid no attention to her. When they heard her singing lullabies that she had composed, the old people began to get suspicious and listened more carefully. They heard her singing, "Now I see the eyes. Now it is beginning to have a mouth," and decided to investigate. The old women and slaves who attended her could find nothing in the room, nor had they ever seen anything unusual. They then sent the girl to a neighbor's house and searched thoroughly. They found the worm under the floor. It had grown so large that its body extended under the whole village and it had eaten all the provisions stored under the house platforms.

When the people saw the face of this monster, they were frightened and held a meeting to decide how they might kill it. They gathered saplings, sharpened the ends and hardened them in the fire, and prepared to spear the creature. As soon as they attacked it, the monster writhed and twisted,

tearing up the whole village. Finally it escaped and started down to the beach, but died as it rolled into the water.

When the girl heard the noise she knew that the people would kill her pet. She came out of the house, singing, "Now I shall go to the place where I shall finish my life." She walked down to the beach where the monster had disappeared and tied herself to a rock, singing a song of mourning for the loss of her "son." Her relatives could not console her nor stop her from carrying out her avowed intention of drowning herself. Finally chiefs and shamans from the other clans came down and promised her anything she might wish if she would come back. When she was nearly covered by the incoming tide she consented and returned to her home.

Several Haida poles were also planned for the Mud Bight village. John Wallace designed and did most of the carving on two poles, the first of which was completed and sent to the project in June, 1941. The second was set up in 1947. (Fig. 62.)

For the first pole Mr. Wallace selected clan and lineage symbols without any particular legends in mind. At the top is the eagle, main crest of his own clan. Below are the beaver and bullhead, also Eagle clan symbols.

The Raven phratry is represented by the raven, and by the bear and blackfish beneath him. The hoot owl at the base of the pole also belongs to the Ravens. It was customary on Haida totem poles, but not on mortuary or grave posts, to carve the crests of a husband and wife, or of a man and his children. Since the Haida, like the Tlingit, traced descent through the mother's lineage, a woman and her children belonged to one phratry—the Raven, for example—and her husband belonged to the other phratry—the Eagle. The Tlingit carved only the crests of the lineage owners on a pole, whether totem pole, grave marker, or mortuary column.

Under the bear's feet Mr. Wallace carved representations of two copper shields. These were beaten from native copper or from sheets of copper procured from the traders and used as media of exchange. They were regularly bought and sold or

given away as highly valued property at the great potlatches. Each copper shield was named, and the value increased with its age and the number of times it had changed hands.

The very large human figure, second from the base of the pole (Fig. 35), is Master Carver or Master Carpenter, who taught the Haida woodworking. Mr. Wallace related the following account of his appearance.

Long ago the Haida did not know how to carve, and Master Carver came and taught them. When he came he wore a carved and painted headdress, and a blanket shirt woven of mountain-goat wool, richly ornamented with designs. His body was tattooed with crest figures. A halo of bright light shone around him, hence he is painted a light color instead of dark as an ordinary human being would have been painted. On his finger nails were human faces, each with a different design and expression. [Because the figure was not large enough to put faces on the nails, Mr. Wallace carved the faces as a necklace for Master Carver.]

When Master Carver appeared to the Haida he told them, "Tonight something will happen. Go to bed as usual and pay no attention to anything you may hear. Don't look until you are sure that the sun is up." During the night the people heard chopping but they covered their heads and restrained their curiosity as he had instructed them. In the morning they saw that the corner posts of the house had been carved and the partition at the back of the house had been painted with animal and human figures. They went outside and there were three carved poles in front of the house, one in the center and one at either corner. The whole front of the house was covered with carved and painted figures. The people were amazed, for these were the first carved and painted figures they had ever seen. They studied everything carefully and tried to copy what they saw.

Master Carver came again and instructed the men. Each day he pointed to one of the faces on his nails and explained the experience behind it. Thus, lesson by lesson, he taught the Haida the secrets of carving. He urged them to study and gave them directions for the different kinds of medicines and training necessary for successful work.

Along each side of the figure of Master Carver, Mr. Wallace carved a fish club ornamented with a shark on the head and a bear on the tail. Both of these are Raven clan crests and tie the crest above with those at the base of the pole. They emphasize

the artistic ideal of the Haida, who could not let even a fish club go undecorated.

On the second pole Mr. Wallace illustrated one of the stories of an encounter with land otters. (Fig. 63.) At the top stands the hero of the story, wearing a dog-skin headdress. His feet are carved in the ears of the figure below; a stylistic device of carrying one carving into another frequently employed by Haida craftsmen. In one hand he holds the tail of a land otter, in the other the carved club with which he killed it. The carving symbolizes the magical power of the club which enabled him to outwit his enemies. Below is a drowned man, holding onto two logs, which the animals use as canoes. He is being taken to the cave home of the land otters, illustrated by a human figure below the logs. According to popular belief, land otters used live mink as paddles, though only a man with strong supernatural powers was able to recognize them. Between the knees of the cave-being is another drowned person, represented as sitting in the otters' den. Such a person was especially dangerous since he tried to entice other victims to share his fate. Anyone who spoke to him or on whom he breathed went out of his mind and became an otter-being also. The next figure is another cave-being, holding a sting ray. At the base of the pole is a devilfish, identified by the beaked face and tenacles. The devilfish is not mentioned in the following version of the story. It was carved to suggest the boulder-strewn beach and rocky, cave-dotted scene of the hero's adventures.

One day he and his family, who were Eagle clansmen, went to Cape Muzon to camp. He took his dog and went hunting in his canoe. A storm came up, and he capsized, but he and the dog were able to swim to shore.

When he reached the beach he quickly killed the dog and put the skin over his head to protect himself from the power of the land otters, whom all Haida dread. He walked along the beach and saw a cave in which two naked men were sitting. Their ears and heads looked like those of otters, but their bodies were still human, and he recognized them as men who had recently drowned.

The next day the man saw two people who looked like his brother and sister coming toward him. He listened carefully and knew from their speech that they were really land otters impersonating his relatives in order to capture him. He killed them with his carved club. Every day some of his relatives came pleading with him to go home with them, and every day he killed them because he knew they were really land otters. The dog skin gave him power to recognize them for what they were.

One day his sister and brother again approached him. He listened to their conversation and they talked correctly. To test them he asked his sister for native tobacco, which she gave him. Then he knew that they were his relatives, for land otters have no tobacco. He went home with them, related all of his adventures, and carved the story to commemorate his escape.

Two Haida mortuary carvings (Figs. 36, 38) were copied for the Mud Bight village. They are both massive sculptures quite different from the slender, elongated figures carved by the Tlingit. The larger size of the cedars available on southern Prince of Wales Island and from the near-by Queen Charlotte Islands partly accounts for the difference in proportions noticeable in Haida and Tlingit carvings. Single-figure sculptures resting on the ground or on very short posts are also more characteristic of Haida grave markers than of Tlingit. Tlingit carvers more often combined two or three figures on a pole about ten feet tall or set a fairly small carving on top of a plain shaft.

The Thunderbird and Whale carving (Fig. 36) came from the old town of Klinkwan. It illustrates the mythological conception of thunder as a huge bird that lives on the tops of the highest mountains. Thunder comes from the beating of its mighty wings. The heavy beak turned back under the chin is an exaggeration of the usual beak with turned-down tip, symbolizing eagles and thunderbirds. The ears, partially destroyed by rot, and the whale, held in the thunderbird's talons, are not visible in the photograph. The whale lies over the top of the

93

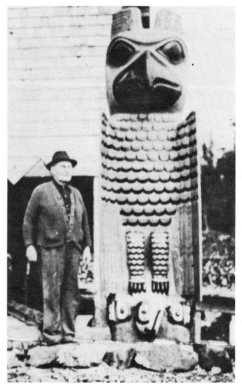

Fig. 36. Thunderbird and
Whale, Klinkwan

Fig. 37. Copy of Thunderbird
and Whale

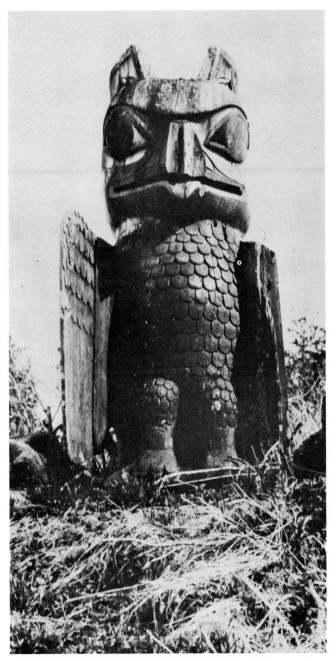

Fig. 38. Eagle Carving, Howkan

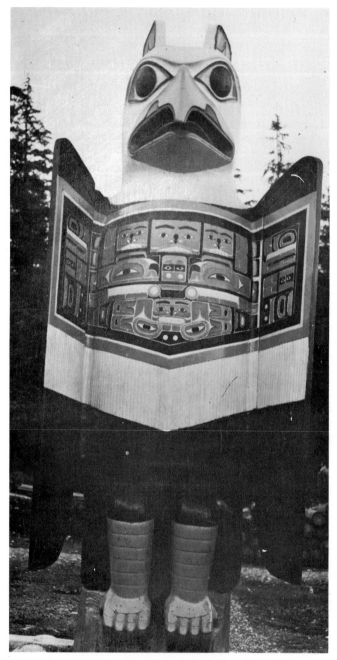

Fig. 39. Copy of Howkan Eagle

short shaft, symbolizing the mountain top where the bird rests after his trip from the sea before devouring his prey. It is said that whale bones may be found on the tops of many mountains, where they have been carried in ages past.

The copy (Fig. 37) is inexact and poor. The shape and angle of the wings are wrong, and the shape of the beak was altered. The carver also failed to reproduce the limp, lifeless form of the whale. The whole carving is stiff and lacks the vitality and feeling of arrested motion achieved by the carver of the original.

The Eagle grave marker (Fig. 38) stood in the old village of Howkan and is one of the most stately and impressive of the southeastern Alaska sculptures. It is five and one-half feet tall, with a diameter through the widest part of over four feet. The feathers and the iris of the eyes were originally painted black, and the beak and feet yellow. The eyes were outlined with blue. Only minute fragments of paint now adhere to the wood, though it is better preserved under the protective covering. The two human land-otter figures lying in the grass were originally kept in the house. They had completely disappeared when the Eagle was removed in 1941.

The copy (Fig. 39) was made without the original, the carver insisting that he could remember it. The result is obviously not a copy, and like the Thunderbird and Whale, only remotely resembles the original. The reproduction of the Chilkat blanket design on the front is entirely out of keeping with wood-carving traditions and would never be used except on a woven blanket or as a painted design on a skin garment. John Wallace, who made the copy, interpreted the design as symbolic of mountains, clouds, and creatures that live in the mountains. The face in the center section, with very large eyes, round nostrils, and prominent teeth, is the mountain itself, and above it are three faces symbolizing clouds. The center one is a fair-weather cloud, those on either side with darkened upper half are light rain

Fig. 40. Totem Park, Klawak

clouds on the mountain top. Below the mountain face is another, symbolizing the homes of animals living on the slopes. On either side of the lower face are whale tails, symbolizing the whales brought to the mountains by thunderbirds.

Except for a small cloud face in the center of either side of the blanket the designs are formal patterns filling space which must be decorated. The painted border and the fringe across the bottom complete the representation of a Chilkat blanket.

KLAWAK
TOTEM PARK

THE SITE for this totem park was selected on high ground adjoining the school at Klawak and overlooking the bay. Klawak is not a port of call for regular passenger steamers and therefore is seldom visited by tourists. Nevertheless, residents felt that the carvings which were familiar to many of them in their old town of Tuxekan should, if moved at all, be moved to Klawak.

All of the carvings at Tuxekan were made either to hold the boxes containing ashes of the dead, or as memorials to deceased relatives. Some of the latter were actual grave markers; others were merely commemorative, not marking the burial locations. There were no carvings which might be called true totem poles or story poles recalling historic events, such as the Lincoln and Seward carvings at Tongass. Nor were there any carved house posts at Tuxekan, such as the Tired Wolf carvings from Village Island and the Beaver posts from a Tongass dwelling.

The Tlingit who made these carvings lived on the northwest shores of Prince of Wales Island. Here, near the northern limit of the western red cedar belt, they found few trees of a size suitable for carving. Moreover, they were on the periphery of the area in which totem-pole carving developed, and their work was later and less complex than that of their southern neighbors. As far as could be ascertained, there are no existing poles in the Tuxekan area that were carved before 1865.

Their poles are slender and the figures are carved simply and with a minimum of detail. A distinctive characteristic is the *squaring* of any portion of the pole left undecorated, and of the

base—the latter often being smaller than the carved figure it supports. Many of the carvings give the impression that the artist started with a squared timber instead of with a log in its natural round shape. Since one of the most typical stylistic features of Northwest Coast art is the absence of sharp angles, either in massive sculptured outlines or in carved or painted detail, Tuxekan work is exceptional.

One of the best sculptures, both in workmanship and in composition, is the illustration of the story of the first blackfish (Fig. 49), though the base figure is too slender to support the well-proportioned blackfish and their creator above. The blackfish headdress worn by the bear (Fig. 55) is also a fine piece of carving and is especially admired by the natives for the uniformly adzed surface, the mark of an experienced craftsman. The bear figure exhibits the small-limbed, long-necked, slender proportions of many other Tuxekan carvings. The square base is so small that it gives the composition a top-heavy appearance.

The whale and the blackfish occur both in Tuxekan legends and as crests of house groups. The two creatures are clearly differentiated. The whale is carved with a flat, dished snout and a small, triangular dorsal fin (see Figs. 42, 53, and 56). The blackfish is distinguished by a thick, blunt head, sharp teeth, and a long dorsal fin (see Figs. 49, 51, 54, and 55).

Other carved figures are much more difficult to recognize. The shape of the beak is the chief means of distinguishing one bird from another. Lacking this all-important symbol, even those most familiar with carvings were unable to agree on the correct restoration of the bird in Figure 41.

MYTHICAL RAVEN
(FIGURE 41)

THIS POLE was carved and dedicated as the final resting place for the ashes of a woman from one of the northern towns, the

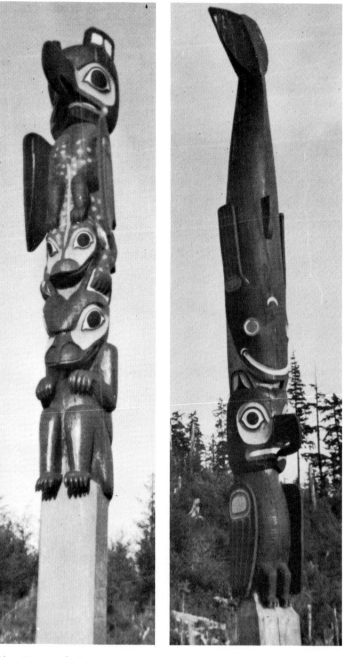

Fig. 41. Mythological Raven *Fig. 42. Raven and Whale*

wife of a Tuxekan man. Nothing could be learned about the particular legends which it was intended to symbolize.

The bird figures on this and the pole in Figure 42 have been reconstructed as the mythical Raven at the Head of Nass, who held the sun, moon, and stars as his personal property, and who is symbolized by a very large, incurved beak. However, there was difference of opinion as to the identity of the character on this pole. Some thought that the carving represented Kadjuk, the fabulous mountain bird, which also belongs to members of the Raven phratry, but to a different house from that to which the Daylight story rightfully belongs. Since the beak was missing from the old pole when recovered for restoration, there is no way of identifying the creature beyond question.

The second figure on the pole is a frog, and at the base is a brown bear.

RAVEN AND THE WHALE
(FIGURE 42)

Two of the many adventures of the mythical Raven are symbolized on this pole. The first is the story of Raven's voyage in the stomach of the whale, symbolized by the carving of the whale.

Raven was walking along the beach when he saw a whale far out at sea. He thought how he might kill the whale. He flew out, and when the whale rose, Raven flew into its mouth. He made a fire in its stomach and cooked the fish swallowed by the great mammal. When he had no fish to eat he cut pieces of fat from the whale's sides. Finally the whale died, and Raven was imprisoned.

He then began to sing, "I wish the whale would drift to a good sandy beach, I wish for a fine sandy beach." Soon they drifted ashore on a beach at the end of a town.

Young people from the village saw the whale and came out to cut it up. As they approached they heard a voice singing, "I wish there was a man strong enough to cut open the whale." The young people were frightened

103

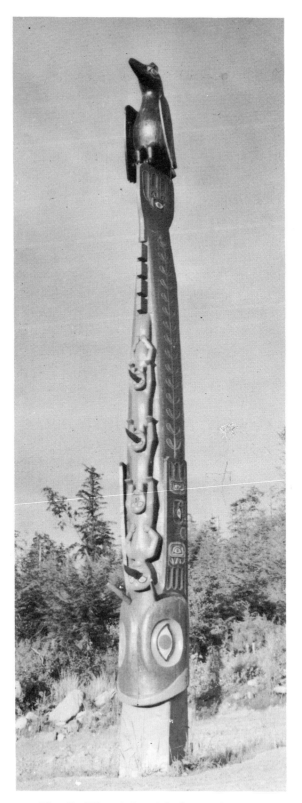

Fig. 43. The Fight with the Land Otters

and went back to the village to report what they had heard. Strong men came back with them and cut open the whale. Raven flew away and cleaned himself, for he was very greasy.

The people made up a song ridiculing the greasy one who had flown out of the whale, though they did not know it was Raven. He was so ashamed that he did not return. The people ate the whale which Raven had intended should be his food.

According to another version of the story Raven turned himself into a man and returned to the village. He told the people that it would be dangerous to eat a whale from which a mysterious voice had come, and this so frightened them that they ran away. He then settled down and consumed the whale at his leisure.

The figure of Raven at the Head of Nass, at the base of the pole, recalls the familiar Origin of Daylight legend (see page 77).

BULLHEAD AND THE FIGHT WITH THE LAND OTTERS
(FIGURE 43)

THE FIGURE of Raven sitting on the tail of the bullhead identifies this as the grave marker of a member of a Raven clan. Along the sides of the bullhead are carved designs representing the backbone, ribs, and skeletal structure of the tail. The pectoral fins are decorated with formal designs. The two spines on the head are characteristic of the bullhead, or sculpin. Together with the broad head and toothless mouth they serve as identifying symbols. On the back of the bullhead are four human beings, their noses elongated to represent the spiny dorsal fins of the fish.

The very large carving of the bullhead emphasizes the importance of the fish as a crest of the lineage of the owners. He appears in a number of Raven stories. The following incident is illustrated by the carving.

105

One day, in his wanderings, Raven was walking along shore looking for food. He saw a piece of jadeite sticking in the ground and picked it up. As he held it in his hand he saw a bullhead swimming in shallow water. He thought how he might get the bullhead to eat. He called out, "This stone says your large head is made only of bone." The fish called back, "Are you sure that is what the jadeite says?" "Yes," Raven replied, pretending to consult the stone, "The stone says you have a big mouth." The bullhead said, "I have known you for a long time," and instead of coming to shore as Raven had hoped, it swam out into deep water and disappeared. Raven was angry and shouted, "From now on you will be thin and bony, and people will not eat you," and so it has been.

The figures carved on the bullhead's back represent the four boys who disobeyed a fundamental law of nature: that no creature should be ridiculed or tortured. Their disobedience brought death to themselves and harrowing experiences to the people of their village. The Tuxekan people were then living at Warm Chuck Inlet, Heceta Island.

Years ago the Tlingit Indians had a summer village at Warm Chuck, where they went during the fishing season to catch and dry salmon. In one of the camps were four boys who decided to go across to Humpy Creek to catch and barbecue salmon. They soon caught many fish so went ashore and built a fire to heat rocks for cooking them. This was done by digging a shallow hole and placing heated rocks in it. Then these were covered with skunk cabbage leaves, and the fish, wrapped in more leaves, were placed on top to cook. Not satisfied with the fish they had secured, the boys built a larger fire on the bank and began catching more salmon, which they tossed on the hot rocks. As the fish wriggled, the boys made fun of them. While they were doing this a frog came near and they tossed it into the fire and made fun of it.

When the fish were baked, the boys ate until they were fully satisfied and then gathered up the remaining salmon, which completely filled their canoe, and started back to the village. Very soon a strong wind arose, and their overloaded canoe swamped and then capsized. The boys clung to the overturned craft and shouted loudly for help. Soon they saw a canoe coming toward them and, as it approached more closely, they thought they recognized their parents and other relatives. However, it was really the land otters, headed by One Who Was Saved by the Land Otters, a man who had drowned and been turned into a land otter. He took the boys into

his canoe, but instead of returning them to their village, he took them to the otters' dens.

When the boys failed to return, their families searched for them and found the dead campfire on Humpy Creek. Returning to the village, they consulted the shaman, Ducksta, and asked him to find the boys. Ducksta had a land-otter power named Kluqua, which he sent to the camp. All the spirit could find was the frog which the boys had thrown into the fire. He sent the spirit out again, and Kluqua discovered the capsized canoe and the boys at the land-otter camp.

Ducksta told the people what his spirit had discovered. They held a council and decided to gather spruce gum and then go to the home of the land otters and set it on fire. Early the next morning they went to the spot indicated by Ducksta and built a fire on the beach. When it was burning well they threw urine on it to make a strong smoke to kill the animals. [Urine is supposed to be especially effective against malicious spirits.] They then retired to their canoes to watch.

The four boys, two women who had been captured, and most of the land otters were destroyed. A white land otter and One Who Was Saved by the Land Otters, who had taken the boys, were saved by jumping into a pond near the den. The tragedy would not have occurred had he not decided to save the boys. The people returned to their village, glad that they had destroyed the animals but sorry that they could not rescue the boys.

Two days later men from the village went seal hunting and as they passed some distance off Cape Lynch they thought they saw two black loons and a seagull sitting on the beach. As they reached shore they discovered that it was really two black land otters bringing fish to a white one. They recognized it as the one that had escaped the fire. The hunters captured it and, wrapping it in a cedar-bark mat, took it back to the village with them. On the way they talked over plans to give a potlatch, as was the custom in those days, inviting another tribe as guests. A member of the chosen guests would be designated as the "deer," or peacemaker, and they would make peace.

As they approached the village they called to the people, who came down to meet them. Right then they agreed to make the white land otter the peacemaker, and the guests would be the land otters. They carried the white land otter into the house and placed it on a new cedar-bark mat in the seat of honor in the farthest corner of the house. Then they scattered eagle down on it as a sign of peace and friendship and kept the fire burning all night to keep it comfortable.

One Who Was Saved by the Land Otters knew what the people were planning because he was one of the black animals left on the beach. He went to every den where the animals were living and invited them to the potlatch, telling them that the people were going to make peace with them.

The following morning just at daybreak the villagers looked out toward Cape Lynch on Heceta Island and saw what appeared to be thick fog rolling in, and from within the fog they heard singing and the beating of drums. As the fog drifted in, they could clearly hear the songs, but since they did not recognize the voices, no preparations were made to welcome the visitors. It was customary for visitors to camp near by until their hosts were ready to welcome them in with songs and dancing. As the fog bank came nearer, the people began to fall asleep one by one, though they did not know they were asleep. Only Ducksta escaped the spell of the approaching land otters.

The visitors landed and went to the community house where the white peacemaker was sitting, led by One Who Was Saved by the Land Otters, who was singing a song. He was wearing a land otter on his head, one on each shoulder, and one on his chest. In each hand he carried a rattle of puffin beaks. As he led the rhythm with his rattles the women lined up and danced. They sang three songs, and as the third drew to a close the people began to come out of their trance. As the song faded away, the land otters, including the white one, disappeared, a white haze or foam at the edge of the beach marking the spot where they had gone. The guests had not waited for their hosts to dance and sing for them, and this worried the people. They feared that the land otters had not accepted their overtures of peace. Because of their uncertainty the villagers decided not to venture out until they had some assurance of the intentions of their guests.

Tiring of the inactivity, four boys decided to go to Warm Chuck Lake, where one of them knew the location of a canoe that had been cached. They found the canoe and started up the lake. Near the head of the lake they saw a strange being. It looked somewhat like a frog, but it was human and was dressed in a bearskin. The creature called to the boys, who, very much frightened, went to it. The creature told them to return to the village quickly and tell Ducksta that he had better hurry to see a shaman stronger than himself, because he was going to die soon. He also told the boys that as soon as they left him the boy sitting in the bow of the canoe would fall over dead, and when they reached the center of the lake the second boy would die, and the third one would die when they reached the outlet. The fourth boy would reach the village and deliver the message to Ducksta, and he too would fall dead.

The fourth boy reached the village and told Ducksta what the person had said and was soon dead. Ducksta was very angry and, dressed in his shaman's regalia, went outside his house and shouted, so that all might hear, that he had power from above and from below and that nothing, not even the land-otter power, could kill him. He had no sooner finished than he began to bleed at the mouth. In a short time he was dead. The spirit powers of Kushtaka, the land-otter man in disguise who had sent the challenge to Ducksta, were much stronger than those of the shaman. The death of Ducksta ended the war between the land otters and the people.

When the pole was set in place in the park, members of the Raven clan owning it invited the Wolf phratry of Klawak to the dedication. Music, speeches, and distribution of gifts appropriately marked the dedication of the new pole, taking the place of the expensive and elaborate potlatch given when the original was set up.

Another pole very similar to this one, but lacking the four men, was erected on St. Phillips Island about fifteen miles from Klawak. Also on the same island was a mortuary pole depicting a land-otter woman. It is a standing figure of a woman about fifteen feet high, with land otters over her shoulders and head and emerging from her breast, and represents the land-otter women of the above story. Both of these poles were moved to Wrangell. They and the one in Klawak Park belong to the same Raven lineage and marked graves of different members.

SOCKEYE SALMON POLE
(FIGURE 44)

THIS CARVING is more complicated than are most of the poles from Tuxekan. It was the mortuary column of a Wolf clansman who owned a sockeye-salmon stream at Deweyville, near Tuxekan. The whole pole advertises the fact of ownership.

The bear represents the house owning the riches in salmon. Below is the titular head holding back his clansmen, symbolized

109

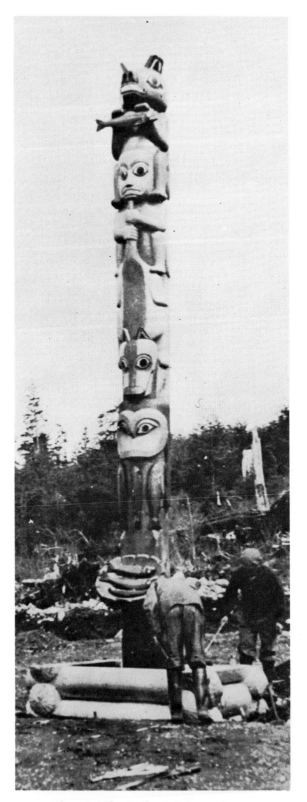

Fig. 44. The Sockeye Salmon Stream

by the wolf, so that they will not be greedy with the fish which it is their good fortune to possess. The entrance to the stream is represented by the face below the wolf. At the bottom are salmon entering the stream and others caught in a trap. The distinctions between the bear and wolf are clearly made on this carving by the long tail and sharply pointed ears of the latter.

The stream which empties from the lake at Deweyville runs through rocky formation so that it almost disappears from view just before it enters salt water. This narrow entrance is represented by the wide-mouthed face. Below it three salmon are leaving salt water for their trip to the spawning grounds. Another explanation of the face is that it represents a basket-work or woven fishtrap with a narrow mouth or entrance, and the salmon are swimming into that. Such traps were set in shallow water at the mouth or along the banks of a stream.

An ingenious trap for catching salmon was made by digging a hole on the beach at the mouth of a stream and building up the sides of it with stones. The fish were driven into the trap and kept there until the outgoing tide left them stranded. Thus the fish were kept in water until wanted. This storage basin, with three fish in it, is represented at the base of the pole.

A serious accident was narrowly averted when the original pole was being moved from the beach, where it had been carved, to the site where it was to be set up. It was being moved by Raven clansmen invited for the purpose when the rope broke and the pole started to roll. In its path were Raven clansmen. The owner stepped in front of the pole and stopped it to save them from injury. He suffered a crushed leg, but saved his clansmen from the necessity of paying for injuries to the opposite side and also from the ignominy of an accident which would have marred the value of their pole. They would have had to pay out much larger sums of property at the raising ceremony if an accident had occurred during its construction or erection.

111

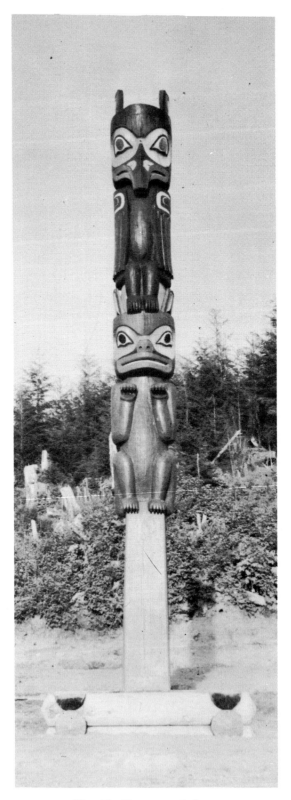

Fig. 45. Mortuary Column

MORTUARY COLUMN
(FIGURE 45)

No ONE WAS found who could identify the person for whom this pole was made or the house group to which it belongs. Everyone agreed that the lower figure is a brown bear, hence the carving belongs to members of a lineage of the Wolf phratry. The narrow turned-down beak of the bird usually symbolizes the owl, which also belongs to certain house groups within the Wolf phratry. Others interpreted the bird as the mythical mountain bird, Kadjuk, but this identification is doubtful, since Kadjuk is a crest of certain Raven phratry members.

THE GIANT CLAM
(FIGURE 46)

THIS MORTUARY COLUMN belonged to a Raven clansman, closely related to Teqahait, who owned Klawak Creek flowing into the bay near the town of Klawak. The pole was brought from Tuxekan and symbolizes Raven's attempt to rid the world of a monster. Another pole belonging to the same group and illustrating the same story stands near the falls above the mouth of Klawak Creek (see Fig. 47).

On top of the pole in Klawak Park is Raven, carved as a hat or headdress worn by his slave. In the slave's hands is the club with which he was supposed to kill the monster clam. On the original pole the slave's hands rested on his knees, and a gun was placed in his lap. The carvers agreed that the incident commemorated on the pole took place long before the Tlingit had guns, so they provided the slave with the ancient weapon when they copied the column. They also added the clam and the small white crab, often found in empty shells on the beach.

Tales of giant bivalves that sucked down canoes or caught unwary individuals and held them until they drowned are fairly

113

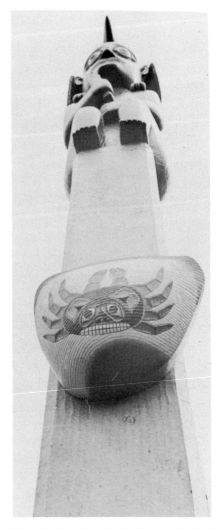

Fig. 46 (a) The Giant Clam *Fig. 46 (b) Detail of Clam and Crab*

common in Tlingit literature. The locale of this particular story was a town on Baker Island where the ancestors of the present owners once lived.

Near the shore of the island was a very large rock in the channel that the people had to pass on their way to and from the village. Under it was the home of a giant clam that was very dangerous. Raven decided to kill it so that it could no longer harm human beings. He called his slave to bring his club, and they went to work.

Raven told the slave to call out, "Raven challenges the giant clam to a fight." The slave started to call out, but forgot what he was instructed to say. Raven told him again, but he called out, "The giant clam challenges Raven," and the monster did not come out. Raven was so disgusted that he gave up and went away.

Later the monster was killed by the people of the village. They made heavy wooden wedges from hemlock limbs sharpened and charred to make them very hard. Then they were greased to make them tough. When the tide was out, the people went down to the rock and waited until the clam opened its shell. They thrust the wedges into it and killed the monster.

RAVEN AND GIANT CLAM
(FIGURE 47)

THE PHOTOGRAPH was taken about 1925 when the carving was still intact. When the pole was seen in 1941 Raven had fallen from his perch and the pole was leaning badly. Pieces of the bird were found in the grass, so rotten that they broke when picked up. Fragments of blue, white, and black paint still adhered to them.

At the base of the slender square shaft is a superb carving of the Giant Clam. On the front of the shell is a face, with very large eyes and the mouth at the hinge edge. A formal feather-tip design ornaments the open edge of the shell. The outline of the eyes had been painted blue, the mouth black, and the feather tips blue and black, though careful examination was necessary to reveal which parts of the carving had been painted.

Fig. 47. Giant Clam Pole on Klawak Creek as It Appeared About 1925

A niche had been cut in the back of the pole through the shell to serve as a repository for the cremated remains of the person to whom the column was dedicated.

The two-foot face at the bottom is that of a woman wearing a labret in her lower lip. Her figure is said to represent a debt owed to the pole owners. They carved her in an effort to shame the debtors into settling the obligation. The fact that the carving is still there shows that no satisfactory adjustment has been made to date. If it had been, the offending carving would have been removed.

GONAQADATE
(FIGURE 48)

THE EAGLE on top of this pole identifies it as belonging to members of a Wolf clan. Below is a woman with a large ornament in her lower lip. Such labrets of bone or stone were marks of wealth and distinction among Tlingit women, but were out of fashion by the end of the nineteenth century. The woman represents the mythical Wealth Woman. On her head is a spruce-root hat with a high, ringed crown which also represents wealth and rank.

According to the legend Wealth Woman carries her infant on her back and two copper shields of great value under her blanket. A man who has fasted and bathed until he is very clean may be fortunate enough to hear the child crying as the Wealth Woman roams through the woods. If he succeeds in locating her and snatching the child from her back, he may demand promises of wealth and good fortune as the price for returning the baby. If he gains particular favor with her, she scratches him on the back with her copper fingernails and tells him, "The scratches will heal very slowly. If you give a scab to anyone who is poor, he will become wealthy. Do not give it

117

to anybody but your very near relatives." He and his relatives will become very rich and will be able to give many large potlatches.

It is not often that a man is fortunate enough to see the Wealth Woman, and very few have ever been able to get close enough to snatch her child, but even hearing the baby cry will help a man in his quest for wealth.

At the base of the pole is another mythical creature, Gonaqadate, who is chief of the blackfish and lives in the sea. A glimpse of Gonaqadate also brings good fortune to the person lucky enough to see him. On this pole Gonaqadate is equipped with both arms and fins, recalling his double role as human being and sea mammal. The story of Gonoqadate is a familiar one to the Tlingit and is symbolized on a number of carvings. A similar story is told by the Haida.[10]

A young man from a very good family married a girl of equally high class from a neighboring village. They lived with his wife's parents in the large community house of which his father-in-law was the head. His mother-in-law disliked the young man very much because she believed that he was lazy and too fond of gambling. As soon as a meal was finished she would instruct the slaves to let the fire go out. As he left the house early in the morning and did not return until after dark the family was through eating before he arrived. He got his own food and sat in the dark to eat it. Then his mother-in-law would say, "I suppose my son-in-law has been felling trees for me, that is why he is so late." The young man did not reply to her scornful remarks.

During the summer when the people went to dry salmon, the gambler went along. He caught and dried some salmon and took it with him to a lake away from the camp. There he built himself a house. He had heard that there was a monster in the lake and he was determined to find out. He felled a cedar tree over the water and split it along its length from the top nearly to the roots. Then he made crosspieces to hold the two sections

[10] An unusually complex carving illustrating a Haida version of the tale stands at the entrance to Totem Park at Sitka. The mother-in-law, dressed as a shaman, sits on top of the pole, enclosed by the trap in which the young man caught the monster. Below are carved the monster, the son-in-law first in human form, and then dressed in the monster's skin with the whale he delivered to the village, and, at the base, the dead monster on the beach.

apart. He baited a line with the salmon and let it down between the two sections. When he felt it move he pulled it up quickly, but the line broke. He again baited the line and let it down. When it moved, he pulled it up so rapidly that the monster could not escape. When its head was in the trap, he pushed out the crosspieces and it was caught.

The monster struggled so hard that the tree was pulled under the water, but it finally died. Then the man took it out of the trap and examined it. It had very sharp, strong teeth and claws that looked like copper. He skinned it, dried the skin, got inside, and went into the water. It began to swim away with him, down to the monster's home under the lake. It was a beautiful house with carved posts and many handsomely carved and painted boxes. After he came up again he left the skin in a hole in a tree near by and went back to camp, but did not tell anyone what he had discovered.

When winter came, the people went back to their village, and during the next spring there was a famine. One evening the young man said to his wife, "I am going away. I will be here every morning before the ravens are awake. If you ever hear a raven call before I get back do not look for me anymore." He went to the lake, got into the monster's skin and swam down to his house. He discovered an outlet to the sea, and swam out. There he caught a king salmon, which he laid on the beach in front of his mother-in-law's house. He put the monster's skin back in the tree and returned home as though nothing had happened.

The next morning his mother-in-law went out early and discovered the salmon. She thought it had drifted there and took it up to her house. She told her husband what she had found and gave the fish to the slaves to cook. Then they distributed the food to all the people in the village, as was the custom. The people were very grateful to their chief, for they were hungry.

The next night after everyone was asleep the young man again got into the skin and swam out to sea. He brought two fine salmon to the village. When his mother-in-law awoke he was sound asleep. She went down to the beach and found the fish, which she distributed as before.

The young man told his wife what he was doing and made her promise that she would not divulge his secret. The third night he brought more salmon and the fourth a large halibut.

When the mother-in-law found the halibut on the beach she thought, "I wonder what this is that is bringing me luck. It must be my spirit power that brings the fish. I believe I am going to be the richest person in the world." She called her husband and her slaves to carry up the halibut.

119

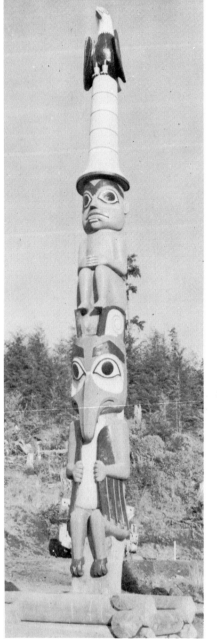

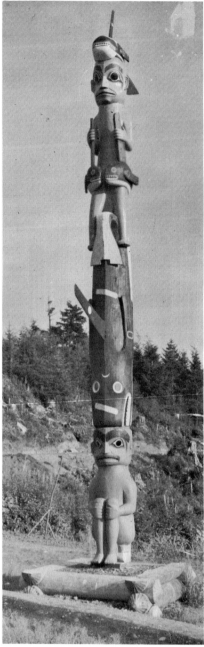

Fig. 48. Gonaqadate,
The Sea Monster

Fig. 49. The First Blackfish

She told her husband that she had had a dream and that no one in the village was to go out the next morning until she gave permission. He went through the village instructing the people. Meanwhile the son-in-law lay in bed and listened to all that was going on.

The next morning he left a seal on the beach. When the woman found it she had it brought to the house and cooked. Then she invited all the people of the village to come and eat it. When they finished she announced that her powerful spirits provided the food to save them from starving. The son-in-law lay in bed and listened to the speeches and the insulting remarks that were made about him, for his apparent laziness and gambling were blamed for their plight.

That night the woman said to her husband, "Have a mask made for me, and let them name it Food-Finding Spirit. Have a headdress made of bear claws." The next day carvers were hired to make these things. Rattles of shells fastened to rings and an apron trimmed with puffin beaks were also made. This was a shaman's costume, for the woman was pretending that she had received shaman's spirits. She put on the outfit and began to dance, saying that her spirits told her she would find two seals on the beach the next day. Her son-in-law lay in bed and listened to her. His wife felt very badly because her mother nagged him continually.

The next morning two seals lay on the beach as the old woman had predicted. The morning after there was a sea lion. The man said to his wife, "Always listen for the ravens. If you hear them before I return you will know that something has happened to me."

The next morning the son-in-law brought a whale and the people were much surprised when the old woman found it. She filled many boxes with oil and meat after the feast was over. They looked upon her as a great shaman.

This went on for a long time, but the young man did not bring in another whale because he had had a hard struggle with the first one. Meanwhile his mother-in-law said spiteful things about him, and the whole village laughed at him, for, as they thought, his mother-in-law provided food for him and his wife while he slept all day.

One night the young man caught two whales and decided to try to take them ashore. He struggled and worked all night, but just as he got them to the beach the ravens cawed, and he died right there. When his wife heard the raven she immediately got up and dressed, for she knew that soon the people would go down to see the monster. Her mother went to the shore as usual and found the two whales lying there with the monster between them. She called the village to see it. It had two fins on

121

its back, long ears, and a very long tail. The people supposed that it was the old woman's spirit.

The wife then came down to the beach weeping and she said to her mother, "Where are your spirits now? If this is your Food-Finding Spirit, make it come to life again. You are only pretending. That is why this happened to my husband." She then directed the people to bring the monster up, and they found her husband dead inside the jaws. He had almost succeeded in coming out of the Gonaqadate skin when the raven cawed.

They took the skin and the body of her husband to the lake and put them in the hollow tree where he had kept the skin. When the people saw the cedar-tree trap and his tools lying about they were convinced that he was the one who had caught the monster and supplied them with food. His mother-in-law was so ashamed that she remained indoors and soon died. When they found her, blood was flowing from her mouth.

Every evening after this the dead man's wife went to the foot of the hollow tree and wept. One evening he came to her and took her to the monster's former home at the bottom of the lake, where they stayed. From there they swam out to sea, where Gonaqadate may still occasionally be seen. Anyone who sees Gonaqadate will be successful in every undertaking thereafter. It is said that good fortune will also come to anyone who sees their children, the Daughters of the Creek, who live at the head of every stream.

THE FIRST BLACKFISH
(FIGURE 49)

THIS POLE illustrates the story of the first blackfish or killer whales, created by Natsihlane, the man at the top of the pole. On his head and around his waist are some of the creatures he made. Another one extends the length of the pole. At the base is his youngest brother-in-law. The niche in the back of this pole is shown in Figure 40.

The locale of the story is Forrester Island. Natsihlane was a Tlingit from the vicinity of Kake. He married and lived in the village of his brothers-in-law. He was a good hunter, but his elder brothers-in-law did not like him because they were jealous of him (see page 81, and Fig. 32).

One fine day the brothers-in-law decided to go hunting. They did not want to take Natsihlane, but the youngest insisted that he be allowed to go along. When they reached Forrester Island they separated, and Natsihlane walked along the beach by himself. When he returned to the canoe he saw that his brothers-in-law were paddling away. He called, "Come and get me. What do you intend to do—leave me here alone?" The youngest brother-in-law tried to pull the canoe back to shore, but the others would not let him and they went away.

Natsihlane felt very sad and wondered whether he would ever see his wife again. He lay down by the fire and went to sleep. He dreamed that someone said to him, "Wake up, I have come to get you." He jumped up and looked around but there was nothing to be seen. He put wood on the fire and went to sleep. Again he heard the voice and awakened. He saw nothing but a seagull walking along the beach. He lay down again and pretended to be asleep, but he watched through the eyehole in his marten-skin blanket. The seagull came close to him, and Natsihlane jumped up and said, "I see you now." The seagull then said, "Come with me. I am the one sent to get you." They went down to the edge of the water, and the seagull directed him to get on his back and close his eyes and not to open them until given permission. Natsihlane did as he was told, and they flew a long time. Finally the seagull said, "Now open your eyes."

They were outside a large building, and the seagull led him inside. This was the home of the sea lions. Their chief sat by the fire. He said, "We know of your trouble and will help you." The chief then instructed his slaves to take down a sea-lion stomach and inflate it with air. They put Natsihlane inside, and the chief said, "Think hard of the fine sandy beach near your village. Do not let your mind wander and do not think of this place." They put Natsihlane in the water, and he started, but he thought of the chief who had helped him. Suddenly Natsihlane was back in the house again.

Again they put him into the water, and this time Natsihlane kept his mind hard on the beach and was soon there. He went into the woods and thought what he would do to get revenge on his brothers-in-law. He got pieces of different kinds of wood and began to whittle.

First he carved eight blackfish of spruce and painted them with stripes of different colors. Then he put them in a row and commanded them to go into the water. They jumped into the water and floated there, but did not come to life. He then tried red cedar, painting them as he had the first ones. He set them in a row on the beach, sang for them, and shouted,

123

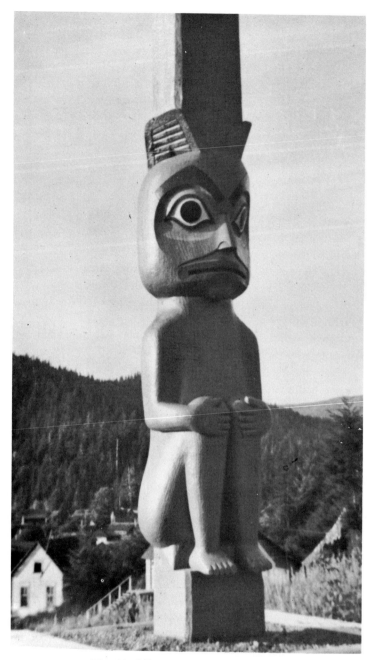

Fig. 50. The Long-Eared Monster

"Go." They swam a short distance and floated, finally drifting back to shore. He tried hemlock, but they were not successful either.

Finally Natsihlane got fine yellow cedar and carved eight blackfish, large and small, as carefully as he could. He painted each with a white band across the head and a white circle on the dorsal fin. He set them in a row as he had the others and, before the ravens cawed in the morning he sang his most powerful songs for them and commanded them to go. They jumped into the water and immediately came to life. They swam about, and soon the little bay was full of foam from their spouting. They brought fish for him and played about in the water.

After many days Natsihlane saw the canoe of his brothers-in-law far out at sea. He called the blackfish in and talked to them, saying, "Destroy the canoe and all of my brothers-in-law except the youngest who tried to help me. Bring him safely to shore." They swam out and around and around the canoe. Watching, Natsihlane saw that the men and craft had disappeared. Two of the blackfish were swimming toward shore side by side and on their backs they carried the youngest brother-in-law.

Natsihlane called all the blackfish to him and lined them up in a row on the shore again. Then he said, "When I made you I did not intend that you should kill human beings. I made you to get revenge on my brothers-in-law. Hereafter you shall not harm human beings but help them when they are in trouble. Now go." They swam out to sea, the first blackfish in the world.

THE LONG-EARED MONSTER
(FIGURE 50)

THIS MORTUARY COLUMN belongs to the same Raven lineage that owns the Bullhead Pole (Fig. 43). The original carving stood on a rocky point of land near Tuxekan, commemorating an experience of Raven clansmen long ago.

According to the legend, Raven clansmen, passing the point en route to the village of Sqa-an, saw a strange creature rise slowly out of the water and then disappear. It looked like a very large man with long, fin-like ears and a human body. They took the monster as a crest of their lineage and named the point Giant Monster Point, the name by which it is still known. The creature is seen occasionally but has never harmed anyone.

125

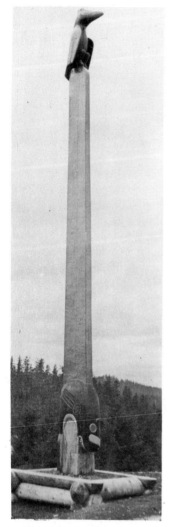

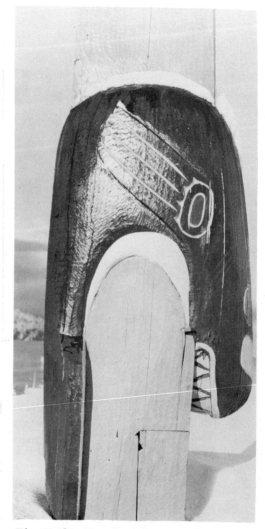

Fig. 51 (a). The Raven-
Finned Blackfish

Fig. 51 (b). Detail of the Diving Blackfish

A Haida carver was commissioned to make the pole. The stylistic cross grooving of the ears is distinctive of Haida carving and is not used by Tlingit craftsmen. It is the only pole in Klawak with such marking.

RAVEN-FINNED BLACKFISH
(FIGURE 51)

THE RAVEN-FINNED BLACKFISH represented on this mortuary column is a mythical crest animal seen long ago by Haida of the Queen Charlotte Islands and brought into Tlingit legendary history by intermarriage. The diving blackfish has a very long dorsal fin, on top of which is the raven. The crest belongs to Wolf clansmen at Klawak, and a box containing the ashes of a clansman was placed in a niche in the back of the pole.

As was true of so many strange experiences that befell the people of long ago, the Raven-Finned Blackfish was first seen by a hunter.

Men were hunting seals when they came upon a school of blackfish that had chased seals into a bay. The hunters followed the seals and were able to spear many of them. One of the men saw a small blackfish. He speared it and threw it into the canoe along with the seals he had killed.

Almost immediately he was surrounded by the blackfish and he could not get his canoe past them to join his companions. Then he heard them discussing whether they should kill him for spearing the child of the blackfish chief. Finally the spokesman said, "The only way you can escape is by paying for the life of the child." Since hunters carried very little with them, the man had only his weapons and a small amount of food. Among his weapons was a sealing spear with a bone point that had belonged to his uncle and had been handed down from uncle to nephew for many generations. The men of this house were famous seal hunters, and much of their success was believed due to possession of this bone point.

The hunter put some food into the water, and the blackfish immediately took it. They asked for more. He put more food in and then some of his small store of native tobacco with baked, powdered shells to be mixed with the tobacco. Still the blackfish asked for more property for their chief's

127

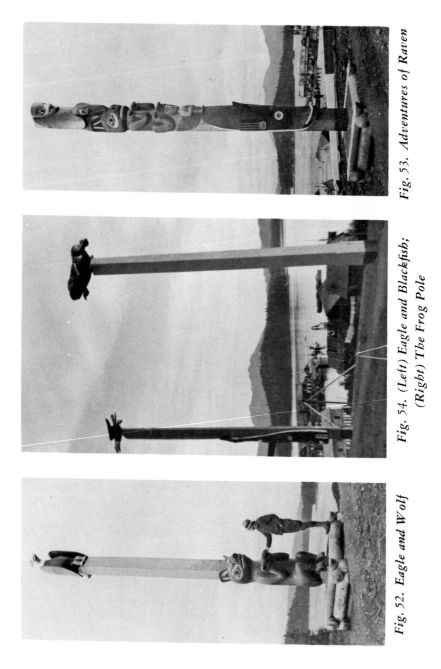

Fig. 52. Eagle and Wolf

*Fig. 54. (Left) Eagle and Blackfish;
(Right) The Frog Pole*

Fig. 53. Adventures of Raven

child. The hunter put one of his weapons into the water. Still the creatures were not satisfied. Finally he had only his bone spear point left. He heard the spokesman say, "He will not give us the valuable thing that we want to pay for the chief's child. Call the chief to talk to the hunter."

Soon he saw a large blackfish coming far out at sea. It had a very long dorsal fin on top of which sat a raven. The chief came near the hunter and told him that only by sacrificing the valued heirloom could he escape with his life, so he put it into the water. The chief then said, "This is what we want, the bone point that has belonged to your uncles for many generations. Only such valuable property will pay for the life of my child." Then the creatures dove and disappeared, and the hunter was left without weapons or food. He was certain that he would starve to death.

Because he had paid for the child, the blackfish sent him food. A seal stranded on the beach, and he ate some of it, though he had no knife to cut it and nothing with which to make fire. Then halibut and other fish drifted ashore, and he filled his canoe. He finally arrived home and told his experiences. He and his relatives had a pole carved to show how the Raven-Finned Blackfish looked. Then they gave a potlatch and related the story so that all the people should know that this crest belonged to the Wolf lineage and all their descendants.

EAGLE AND WOLF
(FIGURE 52)

THIS SIMPLY CARVED COLUMN was the final resting place for the ashes of a woman belonging to a lineage of the Wolf phratry. So far as anyone knew there is no story connected with the eagle and wolf carvings. Apparently the crests were used merely for identification of the clan to which the deceased belonged.

ADVENTURES OF RAVEN
(FIGURE 53)

IT WAS VERY appropriate that this, the first pole to be completed and set up in the Klawak Totem Park, should represent a part of the cycle of stories of Raven the Transformer and Creator, who played such a large part in the legendary history of the

129

Tlingit. Though Raven taught man many useful arts and supplied him with fish, fresh water, and daylight, he was not above playing the part of a trickster, and many are the stories of his gluttony, trickery, and sensuousness.

At the top of the pole is Cormorant, who accompanied Raven on some of his journeys and was his slave when he duped the brown bear, carved just below Raven. The Cormorant face is carved as Raven's tail, and Raven is shown flying downward on the pole. Below brown bear is the whale, with a small human being sitting between the flukes of his tail. These symbolize two additional incidents from the Raven cycle of tales.

When this pole was in place in the park, members of the Raven clan to whom the pole belongs invited the Wolves to a dedication. The people of the village gathered at the park to listen to the band and to speeches explaining the pole and its history. Small gifts were distributed to the Wolf clansmen, recalling the great feast and the distribution of property that marked the setting up of the original carving at Tuxekan.

The three top figures on the pole symbolize the following story."

Raven and Cormorant were traveling and came to a brown-bear camp. Raven turned himself into a woman and married a brown bear. When the bear brought halibut to camp, the "wife" asked for the stomachs of the fish. She cooked the stomachs and filled them with hot rocks, then called her husband to eat them, and said, "People never chew what I prepare. They always swallow it whole." Cormorant tried to tell the bear what Raven had done but Raven pulled out Cormorant's tongue and said, "Cormorant is trying to tell you that the halibut is very good."

After the bear had swallowed the food he began to feel very badly, and Raven directed Cormorant to bring water for him to drink. He drank a large quantity and began to steam inside. Soon he was dead. Raven chased Cormorant away, saying, "Go out and stay on those rocks offshore." Since then cormorants spend most of their time on the rocks, seldom coming to shore.

[11] Since this version differs in a number of details from that told to explain the figures on the Mud Bight poles, it is included here.

Raven did not leave the camp until he had consumed the halibut and bear meat. Then Raven took the bearskin and went on until he came to a camp where children [represented by the small human being on the pole] were trying to cook herring. He showed them how to put a slender stick through each one and how to set it before the fire to roast. Then he thought how he might frighten the children away so that he could eat the herring himself. He put on the bearskin and came into camp, and the children were frightened and ran away. He ate the cooked fish and then went off into the woods to remove the bearskin. When he came back to camp, the children told him what had happened. Raven said, "Cook some more, and if the bear comes back, get clubs and drive it away."

The children put on more herring and played while it was cooking. When Raven came back in the guise of the bear they did as he had told them. He was surprised, for he did not think they would be brave enough to attack a bear. They beat him so hard that he threw off the bearskin and pretended it was just a joke he was playing on them. They all shared the cooked fish and Raven set off for further adventures.

The whale at the base of the pole recalls Raven's trip beneath the sea in the whale's stomach. The story is given in the description of the Raven and Whale carving (Fig. 42).

While the brown bear is one of the principal crests of members of the Wolf phratry, it is carved here as one of the main characters in the story. Raven's marriage to the bear is said to have started the custom of marriage between the opposite sides among the Tlingit.

EAGLE AND BLACKFISH POLE; THE FROG POLE
(FIGURE 54)

THE EAGLE AND BLACKFISH mortuary column belongs to the same branch of the Wolf phratry as the pole shown in Figure 49. The eagle at the top identifies the house group to which the deceased belonged, and the blackfish symbolizes the long narrative of Natsihlane who made the first blackfish. A comparison

131

Fig. 55. Blackfish and Brown Bear

of these two carvings and the one at Mud Bight (Fig. 32) illustrates how widely the symbolizations of a story may vary.

The frog monument was set up in the 1890's on the shore of Tuxekan Passage in memory of a man named Raven's Backbone. His mother was from Tuxekan, and his father was a Tlingit from Wrangell, where the family lived for many years.

The carving is the famous one belonging to the Kicksetti people of the Raven phratry. It recalls the legend of the marriage of a young Kicksetti woman to a frog, who, in the guise of a handsome young man, enticed her to his home at the bottom of a lake (see pages 25 and 80).

The frog was used on the mortuary column of Raven's Backbone because it belonged to his father's father, hence to members of his own Raven phratry. It also serves to commemorate his relationship to people of the northern town. It does not belong to any Tuxekan or Klawak groups.

BLACKFISH AND BROWN BEAR
(FIGURE 55)

THE BROWN BEAR on this mortuary pole identifies the clan of the Wolf phratry to which the owners belong. It was dedicated as the final resting place of a woman member. Her father was Gunga, whose lineage owns the Dog Eater Spirit pole illustrated in Figure 59.

The twelve-foot blackfish, carved as a headdress worn by the bear, represents a wooden hat owned by the deceased woman and her relatives. Such hats were elaborately carved and painted with designs symbolizing the same legendary history that was illustrated on the poles. They were worn only during potlatches and other ceremonial occasions and were handed down as heirlooms.

No one could be found who knew what particular legends are symbolized by these two figures.

Fig. 56. Poles on Klawak Creek

RAVEN AND WHALE
(FIGURE 56)

THIS AND THE Eagle and Sea Monster pole illustrated in the same photograph are located near the mouth of Klawak Creek and were not copied for the totem park. The Raven and Whale carving was set up as the last resting place of Teqahait, head of Raven House, the group which owned Klawak Creek. The abundant supply of sockeyes in this stream was the main reason for the location of the commercial cannery near by, which in turn attracted the Tuxekan people and resulted in abandonment of their old town.

The finely proportioned, graceful carving of this pole contrasts sharply with the high degree of conventionalization so characteristic of most Northwest Coast art. The effect of a slender shaft is achieved by carving the whale's body as an integral part of the pole instead of as a figure in relief on the front surface. (Compare the whale carvings in Figures 42 and 53.) The downward flight of Raven diving into the whale's mouth is emphasized by the spread tail and half-closed wings.

The carver engraved the wing and tail feathers of Raven with great care, though all of his lines are shallow compared with the majority of carvings. The pectoral fins and the dorsal fin, which has fallen off, were left undecorated. The whole surface of the whale is covered with very small, almost minute, adze marks placed with a regularity that required great dexterity. Compared with this artist's work the finishing of the sea monster's body (Fig. 57) is coarse and heavy.

The story of Raven's adventures in the stomach of the whale is symbolized by this carving. The same tale is illustrated on the poles shown in Figures 42 and 53. (See page 103.)

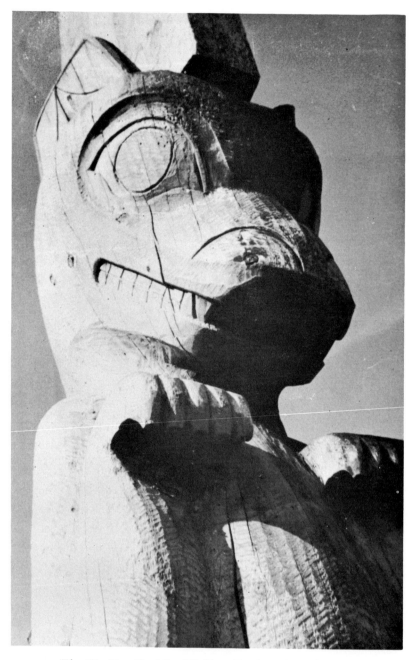

Fig. 57. Detail of Sea Wolf on Eagle and Wolf Pole

EAGLE AND SEA MONSTER
(FIGURES 56, 57)

THIS CARVING was dedicated to the memory of Teqahait's wife, who died several years after her husband. The eagle at the top identifies her house group or lineage.

The figure at the base of the pole is a wolf, but the tall, slender dorsal fin, rising between the wolf's ears to form the shaft of the pole and a resting place for the eagle, is symbolic of the mythical sea monster, a creature familiar to all Northwest Coast tribes. It is not Gonaqadate, though the same characteristics are sometimes attributed to the two creatures. The sea monster is described as having a wolf's head and whale's body. However, artists have not always adhered to the description. The necessary identifying marks of the monster are a wolf head and a whale's dorsal fin. Having supplied these, the artist might combine the wolf and whale body in any way he chose. In this carving the wolf was supplied with a dorsal fin and thus represents the sea monster. Other combinations observed are: wolf body with fins instead of legs, whale body with legs, wolf body with both legs and fins, and wolf body with fins and a long, jointed tail.

THE SPIRIT OF HAZY ISLAND
(FIGURE 58)

ONLY THE MAN at the base of this pole could be salvaged when the old carvings were brought from Tuxekan. Like all exposed and dead wood, it had weathered to a soft silvery hue. The new pole was in the workshop at the end of the project and has not been set up in the park. No photograph of it was available.

The carving belongs to the Winter People, a clan of the Wolf phratry who once had a fortified town on Hazy Island called Fort Far Out. The island, now a bird reserve, is a nesting place

137

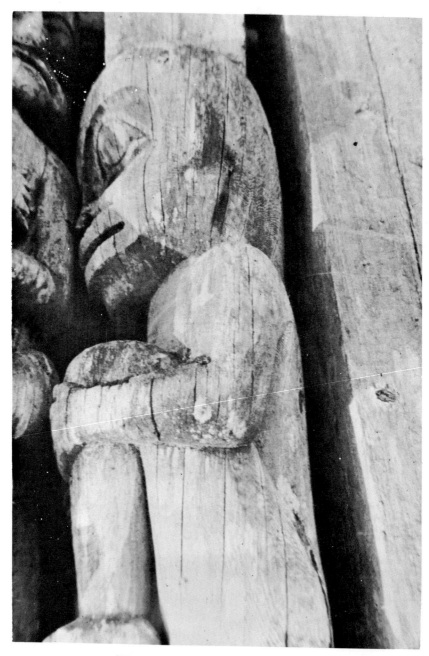

Fig. 58. The Spirit of Hazy Island

for myriads of sea birds, the murre among others. The Winter People had the exclusive right to gather murre eggs from the island, and they regard the bird as one of their special crests. Used as a tattoo design and carved on wooden articles, it serves to publicize their ownership of the island as well as to identify members.

Two murres were carved for the top of the copy. They were painted with black heads, brown backs, and white breasts. Carved models of their eggs were pegged to the front of the shaft. The eggs were painted grey with brown, blue, and green markings or green with brown, white, and blue markings, no two of the twenty-six exactly alike. According to legend, the murres spend much of their nesting time painting their eggs so that each pair can recognize its own among the great number lying about on the bare rocks.

The human figure at the base of the pole recalls another tradition of Hazy Island. Long ago a man went to the island but was caught in a storm before he could land. His canoe was wrecked, and the wind and waves washed him right through an underwater hole in the rocks. His spirit still dwells there, where he may be heard during storms. People going to the island put a little food in the water and ask this spirit for good weather and a safe journey. The island spirit helps those who observe the rules of good conduct and respect for wild life. Misfortune is sure to come to those who are frivolous or who disregard the strict laws of food conservation and proper use of resources. The spirit withdraws his protection from such people, and they are in danger of losing their canoes or their lives.

FLICKER POLE

THE FLICKER is also a special crest of the people who own the Murre. No photograph was available of either the old pole or

the copy, which was still in the workshop at the end of the project.

According to legend, Raven's mother owned the first flickers, which she kept hidden in her armpits. When Raven released the sun, moon, and stars he also liberated flickers. Later on when he gave all the birds their present plumage and characteristic forms, he gave flickers their color and habits.

On the pole the bird is carved sitting on a stump, since Raven decreed that flickers should stay deep in the woods and seldom be seen in the open. It is painted in natural colors with the orange-red of the throat and wing feathers emphasized. The flicker feather has been conventionalized and is frequently used in Northwest Coast art as a formal element in painted and carved designs.

Flicker-wing feathers were also used to ornament a particular style of headdress with a carved wooden plaque in front and weasel skins hanging down the back. They were owned by wealthy men and worn only at potlatches and other festive or solemn occasions. When a man had such a headdress made for himself he selected one of his crests or a character from one of his lineage's legends to be carved on the plaque. The use of flicker feathers is noteworthy because Northwest Coast natives, unlike Indians of the Great Plains, seldom used feathers in the ornamentation of their headdresses or costumes.

The stump on which the flicker sits is carved in the form of a man sitting with his knees drawn up in front of him. Personification of inanimate objects is characteristic of native carving and represents the belief that even a tree that is cut has a spirit or life. Stump is the leading character in one of the Raven stories. The two got into an argument, and Stump threw himself across the fire over which Raven was roasting salmon and thus deprived him of a meal.

Other personifications on Tlingit poles include a salmon stream, a rock, and Devil's Thumb, a mountain in the coast

140

range. Usually, details such as eyebrows and ears, which identify the subject as a human being, are omitted in the representation of an inanimate object.

KATS THE BEAR HUNTER

ANOTHER POLE copied for the Klawak Totem Park, of which no photograph was available, symbolizes the story of the hunter who married a bear. The legend belongs to the Seal People of Angoon and Saxman (Tongass), a clan of the Wolf phratry. The carving at Tuxekan was set up in memory of a descendant of the Tongass wife of a Tuxekan man.

There were only two figures on the original pole. Kats, wearing a tall spruce-root hat, was at the top. Below him was a very large figure of his bear wife. The carvers of the copy added the male bear in the act of seizing Kats's two dogs as they tried to enter the den. With their sharp muzzles and pointed ears they look like wolves. The carvers explained that dogs in those days were wild and wolflike. They also added a carved and painted face to the brim of Kats's hat, but the face, they said, was not intended to represent any creature, real or mythical. This carving illustrates the same story as that related on page 31.

THE DOG-EATER SPIRIT
(FIGURE 59)

ON THE TOP of this pole is a man holding the limp body of a dog in his arms. Below is the head of the brown bear, the crest of the Wolf clansmen who own the pole.

This pole is unique. It is the only Klawak carving, with the exception of the copy described above, on which a dog is represented, and one of the very few from the entire totem-pole area of southeastern Alaska and the coast of British

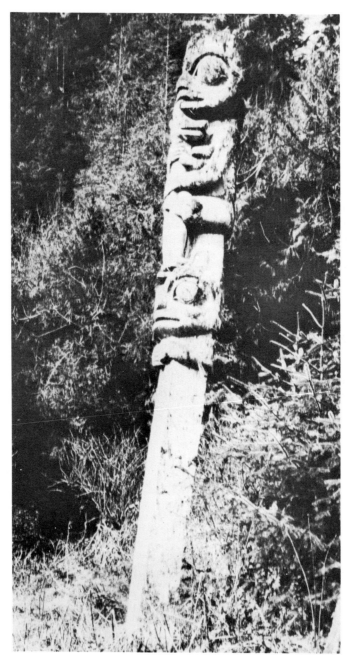

Fig. 59. The Dog Eater

Columbia. Dogs were never taken as crests nor utilized as identifying insignia by any of the house groups or clans. In all the tribes of the Northwest Coast certain powerful spirits influenced men. One of these was the dog-eater spirit, which caused those under its influence to lose all control over their actions. Only by eating dog flesh could the spirit be quieted and the victim return to his right mind. Among the Tlingit the right to the dog-eater spirit was jealously guarded by the few men who had bought the privilege from the Tsimshian of Nass River. A demonstration of its power involved expensive feasting and entertainment and provided one of the means by which parents enhanced the social position of children—or perhaps only of sons, since it has been reported that Tlingit girls were not brought under the influence of the dog-eater spirit.

The above pole was put up after the death of a man whose name is now forgotten. He was an ancestor of Gunya, whose acquisition of the dog-eater power in the late nineteenth century is the last one remembered to have taken place at Tuxekan. The occasion was a potlatch given by Gunya's father. While the guests were watching the entertainment, Gunya was sitting by the fire. Suddenly the guests noted that he was becoming agitated, and helpers, previously selected by his father, came forward to dance around the boy. The dancing became faster until suddenly, in the midst of the dancing men, Gunya disappeared. This was, of course, according to plan, but it greatly mystified the uninitiated, who were told that the dog-eater power had spirited Gunya away, and his clothes were brought in from the woods as proof.

During Gunya's absence the helpers selected by his father danced and sang for him, trying to contact the spirit that was causing him to wander. Keda, experienced in the ways of the spirits, was in charge of the attempts to get Gunya back. When day after day went by without word of him, his family threat-

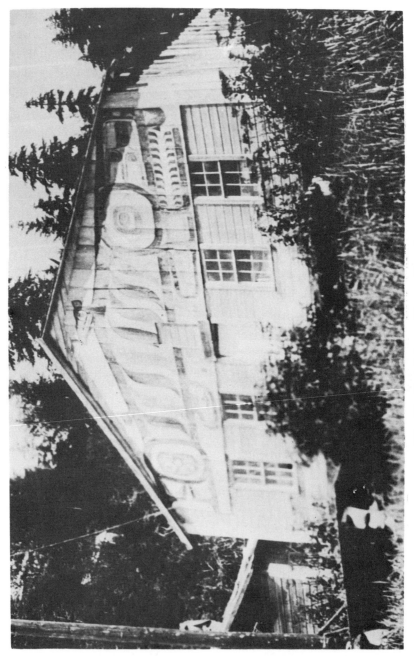

Fig. 60. Dog Salmon House, Tuxekan

ened to kill Keda, for it was in the middle of winter and they were sure their son must have frozen to death.

During the morning of the eighth day Gunya was heard singing around the point from the village. Keda and the helpers went to look for him and found him walking along the beach in the water. He was naked and he held the head of a dog in his arms. The people were afraid of him, but his uncle waded into the icy water and pulled Gunya in by his hair. On shore a heavy cedar-bark rope was fastened around his waist and he was taken to his father's house.

There the helpers danced and sang until the spirit power was subdued and Gunya was able to tell of his experiences under its influence. He related that when he first came to himself after the power spirited him away, he was on top of Tokeen Mountain, about fifteen miles from Tuxekan. He heard singing, which was really the songs of Keda and his helpers calling him back to the village. The next time he was conscious of his surroundings he was at the salmon stream at Deweyville. He was cold and naked and cried because of his plight. Then he again succumbed to the powerful influence of the spirit and was not aware of his actions or location until he "came to" in his father's house surrounded by his friends. It was several weeks before the influence of the spirit was entirely removed and Gunya was normal again.

The above pole was to have been copied for the totem park, but this had not been done when work on the project was terminated.

DOG SALMON HOUSE FRONT PAINTING
(FIGURE 60)

THIS WAS the only house in Tuxekan ornamented with a painting on the front. The porch was supported with carved posts, and the flagpole in the foreground had the figure of a slave

145

carved at the base. The slave belonged to a group who owed the house owners a debt, and they carved him to hold the rope for their flag in an effort to shame the debtors into settling the account. Like the rest of the houses in the village, this one has collapsed into moldering ruins.

The use of paintings symbolic of the house owners' legendary history was never common among the Northwest Coast Indians. It was a development of the late era of native art after milled lumber and a variety of tools had become available.

This dwelling was named Dog Salmon House, and the owners were known as the Dog Salmon people, commemorating the adventures of an ancestor of this lineage of the Raven phratry. Their legend is known and related by a number of lineages, all of whom claim the hero of the tale as their ancestor.

While the painting resembles usual representations of the blackfish with its blunt head, teeth, and round eye, it is a dog salmon. The dorsal fin is painted as a raven's head, symbolizing the clan of the owners. Another, smaller raven's head appears near the tail. The elaboration of the tail into a face is a common stylistic device, as is the painting in of ribs to fill an otherwise undecorated surface. The story of the Dog Salmon House is as follows:

Boys were playing on the beach snaring seagulls, and one of them was hungry. He ran into the house and asked his mother for something to eat. She gave him a piece of dried salmon. He said, "Why do you always give me this moldy salmon?" and threw it down. He went back to the beach and found a seagull in his snare. He waded out to get it and the bird pulled him out to sea. He disappeared.

The boy was taken by the salmon to their village and to their chief's house with a painting on the front of it. He did not know that he was in the salmon town, as they all looked like human beings to him. Because of what he had said they called him Moldy End. When he was hungry, one of the salmon gave him a small stone to chew on. A salmon on the way to spawning grounds never eats, but by keeping a small stone in its mouth it never grows hungry. One day Moldy End lost his stone and became very hungry. A companion instructed him to club one of the children playing

in the village and roast it, being careful to gather up and burn all the bones and refuse. He did as he was instructed but overlooked a tiny piece of bone from under the eye, which had fallen into a hole. When he returned to the chief's house he found the chief's son ill. His companion told Moldy End to go back and search his campfire carefully. They found the bone, and his companion said, "Throw it into the water quickly." He did, and the chief's son was well. This is said to be the origin of the custom of disposing of all fish bones so that the salmon might revive and return the next year.

When Moldy End became lonesome, the salmon took him to Amusement Creek, where there was dancing and other entertainment, and he forgot his homesickness.

In the spring the salmon prepared to return to the streams to spawn. The chief took his people to the creek where the parents of Moldy End lived. His mother saw a large, silvery dog salmon jumping and urged her husband to try to catch it. He speared it and brought it to her. She started to cut it up and her knife struck something hard around the neck. It was her son's copper necklace. She called her husband, and they laid the salmon on a cedar-bark mat and put him on top of the house. He was transformed into a boy again and told his experiences and the things the dog salmon had taught him about their life. His descendants took the dog salmon as their special crest to commemorate his adventure. Their house-front painting is a copy of that on the front of the salmon chief's house.

The Dog Salmon people owned a carved pole at Shakan with a brown bear and salmon on it, set up as a public record of a debt owed them. The bear belonged to a Chilkat house group whose members had borrowed twenty copper shields and a slave from the Dog Salmon people for a potlatch. They were very slow in repaying the debt, so the house head had a pole carved with a salmon resting on the arms of the bear. The import of the carving was that the Dog Salmon people would crush the Bear people unless the debt was paid.

ADDENDA

SEVERAL POLES were completed and set up at Mud Bight after the material for this account had been prepared. Photographs were received after it had gone to press. In order that the description may be as complete as possible they are included here.

Three additional Tongass poles were copied. A chief in a spruce root dance hat tops Figure 64. At the base is the chief, Raven at the Head of Nass, from whom Raven stole daylight. The small human figure represents ancestors of the Raven clan who were benefited by the theft. The original of the second pole (Fig. 65) stood in front of Forrested Island House at Tongass. It symbolizes the story of the origin of blackfish. (See page 81.) The raven, carved with the dorsal fin of the blackfish extending above him, is a special crest. The tiny face on each blackfish represents the blowhole. The third Tongass carving is of the bear and tracks, symbolizing Kats's bear wife. A similar carving stands in Ketchikan Park (Fig. 31).

The well executed halibut carving (Fig. 66) is not a copy, but honors the Halibut House people of the Nexadi clan.

A pole carved by John Wallace (Fig. 67) resembles one from the deserted Haida village of Klinkwan, which was copied for the Hydaburg Totem Park. A village watchman stands guard at the top of the pole. Below are two eagles, crests of certain Haida Eagle clans. Below them are painted faces representing mountains and clouds, habitat of eagles. The large figure below is a blackfish in supernatural form, holding a seal. Above the blackfish is a small, carved face; a personification of the undersea home of the creature. The mythical sea monster, with a peculiar duck-like beak, appears on a number of Haida poles. The small face under the beak is the monster's spirit power. Tenacles with a face beneath represent a devilfish in the act of devouring the human being at the base of the pole. In the background of the photograph is a copy of the Thunderers from Tongass. The original pole stands in Ketchikan Park (Fig. 31).

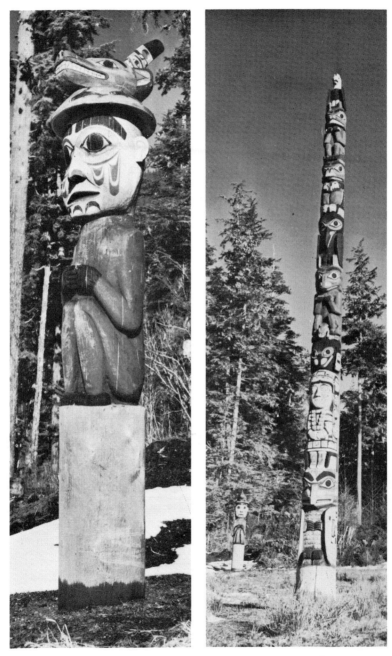

Fig. 61. Man with Bear Hat *Fig. 62. Master Carpenter*

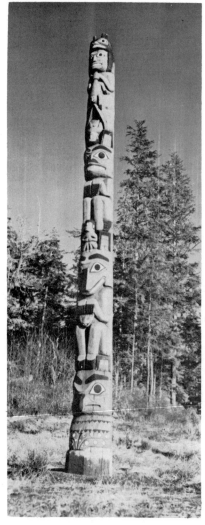

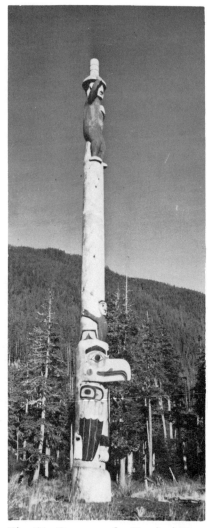

Fig. 63. Man Captured by Land Otters

Fig. 64. Raven at the Head of Nass

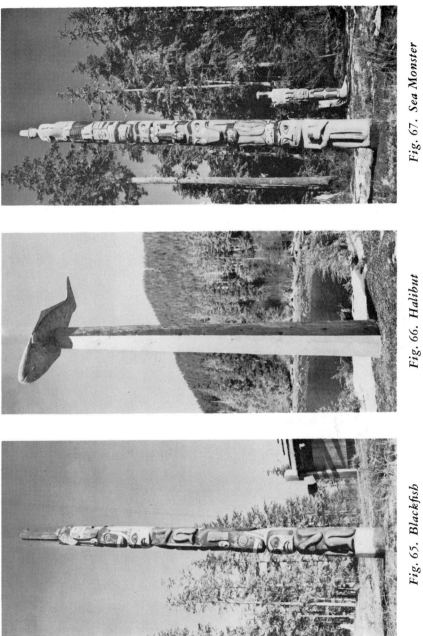

Fig. 67. *Sea Monster*

Fig. 66. *Halibut*

Fig. 65. *Blackfish*

BIBLIOGRAPHY

The bibliography includes descriptions of the arts of Northwest Coast Indian tribes other than the Tlingit and the Haida. It also includes books on arts other than totem pole carving.

Barbeau, Marius. 1929. Totem poles of the Gitksan. Canada Dept. of Mines, Nat. Mus. Canada Bull. 61, 275 p.

————. 1950. Totem poles. 2 vols. Nat. Mus. Canada Bull. 119, Anthropol. Ser. 30, 880 p.

————. 1953. Haida myths illustrated in argillite. Nat. Mus. Canada Bull. 127. Anthropol. Ser. 32, 417 p.

————. 1957. Haida carvers in argillite. Nat. Mus. Canada Bull. 139. Anthropol. Ser. 38, 214 p.

————. 1958. Medicine men on the North Pacific coast. Nat. Mus. Canada Bull. 42, 95 p.

Boas, Franz. 1895. The social organization and secret societies of the Kwakiutl. U. S. Nat. Mus. Report, 311-738.

————. 1897. The decorative art of the Indians of the North Pacific coast. Bull. Am. Mus. Nat. Hist. 9, 123-76.

————. 1955. Primitive art. Dover Press, New York. 378 p.

Davis, Robert T. 1949. Native arts of the Pacific Northwest. Stanford Univ. Press, Stanford, Calif. 165 p.

Douglas, Frederic H. and René d'Harnoncourt. 1941. Indian art of the United States. Mus. Mod. Art, New York. 219 p.

Drucker, Philip. 1955. Indians of the Northwest coast. McGraw-Hill Book Co., New York. 208 p.

Duff, Wilson, 1952. Gitksan totem-poles. Anthropol. in Brit. Col., 3: 21-30.

Emmons, George. 1903. The Chilkat blanket. Mem. Am. Mus. Nat. Hist., 3: 329-400.

————. 1916. The whale house of the Chilkat. Am. Mus. Nat. Hist., Anthropol. Paper 19, 33 p.

Garfield, Viola E., et al. 1951. The Tsimshian: their arts and music. Publ. Am. Ethnol. Soc., 18. 290 p.

Grinnell, George B. 1901. Natives of the Alaska coast region. Harriman Alaska Expedition, I: 137-64.

Haeberlin, Hermann K. 1918. Principles of esthetic form in the art of the North Pacific coast. Am. Anthropologist, 22: 258-64.

Inverarity, R. Bruce, 1950. Art of the Northwest coast Indians. Univ. Calif. Press, Berkeley, Calif. 262 p.

Keithahn, Edward L. 1945. Monuments in cedar. Roy Anderson, Ketchikan, Alaska. 160 p.

Krause, Aurel [trans. Erna Gunther]. 1956. The Tlingit Indians. Univ. Washington Press, Seattle. 310 p.

Newcombe, William A. 1930. Guide to the anthropological collections in the provincial museum. Charles F. Baufield, Victoria, B.C. 80 p.

Niblack, Albert. 1890. The coast Indians of southern Alaska and northern British Columbia. U. S. Nat. Mus. Annual Report for 1888, 225-386.

Paul, Frances. 1944. Spruce root basketry of the Alaska Tlingit. Haskell Institute, Indian Handcrafts 8. 80 p.

Swanton, John R. 1909. Contributions to the ethnology of the Haida. Mem. Am. Mus. Nat. Hist., 8. 300 p.

Wingert, Paul S. 1949. American Indian sculpture: stone carvings of the Pacific coast. J. J. Augustin, New York. 144 p.

UNIVERSITY OF WASHINGTON PRESS

Other Books on the Indians and Eskimos

THE TLINGIT INDIANS
Results of a Trip to the Northwest Coast of America and the Bering Straits
By Aurel Krause. Translated by Erna Gunther. 1956. Illustrated

ARTISTS OF THE TUNDRA AND THE SEA
By Dorothy Jean Ray. 1961. 104 photographs, 8 drawings

THE INDIANS OF PUGET SOUND
By Hermann Haeberlin and Erna Gunther. 1930. Illustrated. Paper

THE PEOPLE ARE COMING SOON
Analyses of Clackamas Chinook Myths and Tales
By Melville Jacobs. 1960. Paper

ADZE, CANOE, AND HOUSE TYPES OF THE NORTHWEST COAST
By Ronald L. Olson. 1927. Illustrated. Paper

THE WHALING EQUIPMENT OF THE MAKAH INDIANS
By T. T. Waterman. 1920. Illustrated. Paper

PETROGLYPHS OF CENTRAL WASHINGTON
Rock Paintings Described and Interpreted
By H. Thomas Cain. 1950. Illustrated. Paper

And on the Pacific Northwest

"HE BUILT SEATTLE"
A Biography of Judge Thomas Burke
By Robert C. Nesbit. 1961. Illustrated

SURVEYOR OF THE SEA
The Life and Voyages of Captain George Vancouver
By Bern Anderson. 1960. Maps, engravings

MERCER'S BELLES
The Journal of a Reporter
By Roger Conant. Edited by Lenna Deutsch. 1960. Illustrated

**HISTORY AND GOVERNMENT OF THE
STATE OF WASHINGTON**
By Mary Avery. 1961. Illustrated. Paper and cloth

BIRDS OF WASHINGTON STATE
By Stanley G. Jewett, et al. 1953. 111 plates, 52 maps

SPRING FLOWERS OF THE LOWER COLUMBIA VALLEY
By Clara Chapman Hill. 1958. 71 drawings

ROADS AND TRAILS OF OLYMPIC NATIONAL PARK
By Frederick Leissler. 1957. Maps, photographs. Paper

GEOLOGY OF OLYMPIC NATIONAL PARK
By Wilbert R. Danner. 1955. 51 illustrations. Paper

THE PENTHOUSE THEATRE
Its History and Technique
By Glenn Hughes. 1942, revised 1958. Illustrated. Paper

**THE "101 WILDFLOWERS" SERIES OF
NATIONAL PARK GUIDEBOOKS**
By Grant and Wenonah Sharpe. Illustrated. Crater Lake, Mt. Rainier and
Olympic. Paper